Wildlife
Photographer
of the Year
Portfolio 27

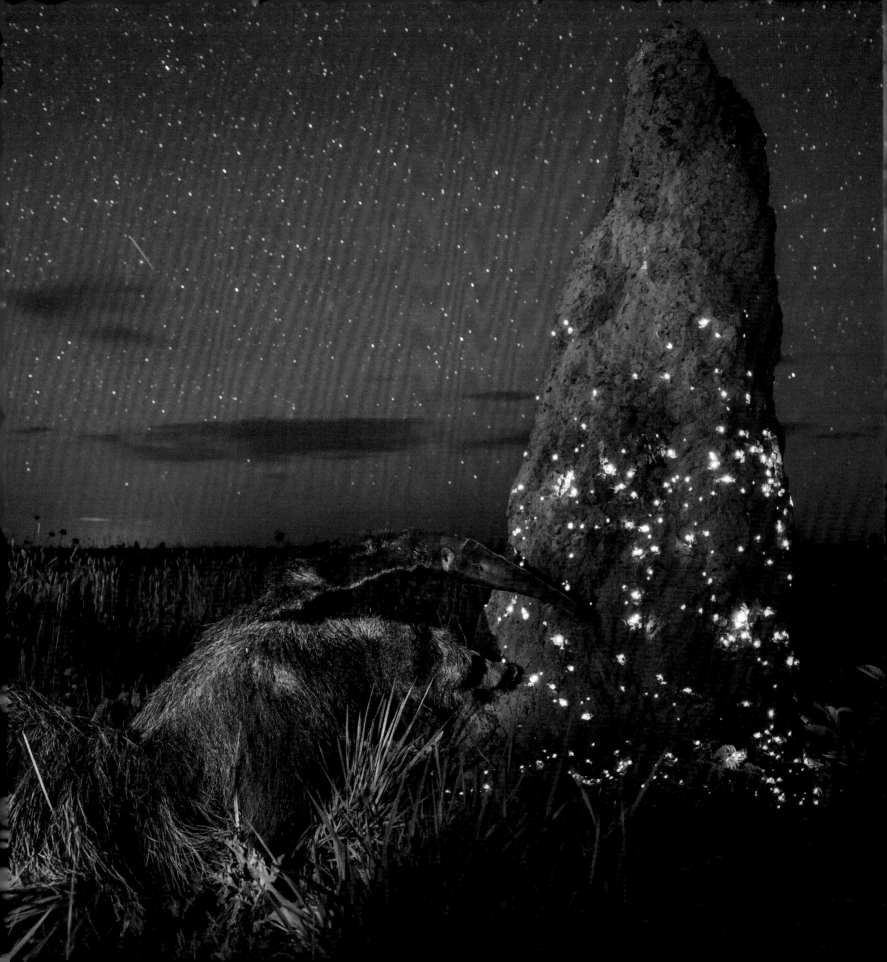

Wildlife
Photographer
of the Year
Portfolio 27

Published by the Natural History Museum, London

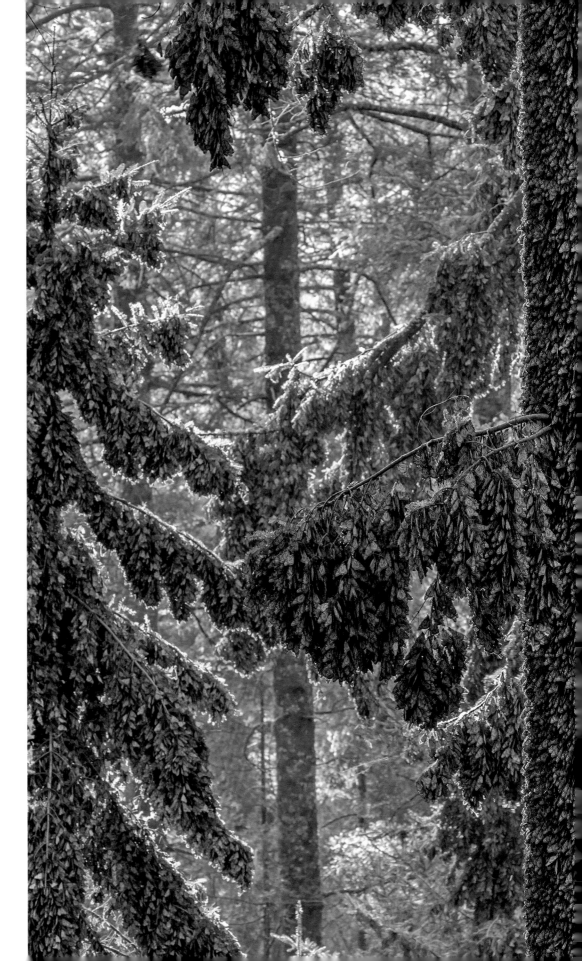

First published by the Natural History Museum,
Cromwell Road, London SW7 5BD
© The Trustees of the Natural History Museum,
London, 2017
Photography © the individual photographers 2017

ISBN 978 0 565 0 94157

A catalogue record for this book is available from
the British Library.

Editor: Rosamund Kidman Cox
Designer: Bobby Birchall, Bobby&Co Design
Caption writers: Tamsin Constable, Anna Levin and
Jane Wisbey
Image grading: Stephen Johnson
www.copyrightimage.com
Colour proofing: Saxon Digital Services
Printing: Gorenjski tisk storitve d.o.o., Slovenia

FSC
www.fsc.org
MIX
Paper from
responsible sources
FSC® C057358

right: Jaime Rojo, A magnificence of monarchs
previous page: Marcio Cabral, The night raider
foreword page: Justin Hofman, Sewage surfer
competition page: Wade Hughes, The look of a whale

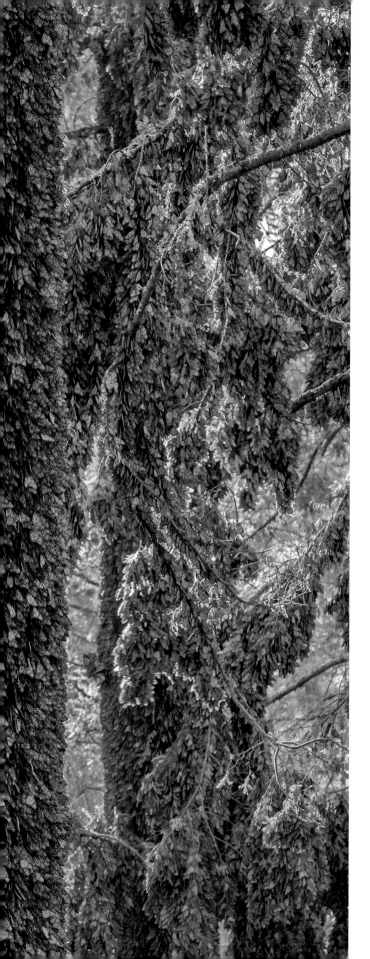

Contents

Foreword

Welcome to Portfolio 27, a record and showcase of one of the world's most respected and most visited annual awards, Wildlife Photographer of the Year.

It is a great honour to chair the expert jury, which this year winnowed down nearly 49,000 entries to the 100 that made the exhibition and this book. These are showcased at the Natural History Museum in London and in many other locations around the world. This exhibition combines outstanding photographs with the stories behind the images, of both the behaviour and how the pictures were taken. But it falls to me now to ask what we have achieved with our selection. What can it *do*?

It would be easy to say that this year's choice of overall winning image is a call to action. It may be seen as a statement from the jury that we must all – at least all who care about wildlife and the safekeeping of the planet – band together and work harder to stop the destruction of the natural world. Given the savagery and statistics behind Brent Stirton's story of rhinoceros poaching, it might be thought that we must do this with the greatest urgency and with every force we can muster. Beyond the images, worldwide data indicate we are at crisis point, with the collapse of environments and species. The awful image of one slaughtered and dehorned rhino might be a symbol of the devastation that is taking place in so many places, with so many creatures destroyed, with fragile ecosystems smashed and the fabric of our existence, too, under clear threat from man-made damage.

The overall winning image and its story sit in the company of other tough messages in this year's selection, succeeding other grisly images in years past. And even behind some of the quieter and more apparently appealing images, the facts of species collapse or habitat loss continue to pile up.

However, as chair of the Wildlife Photographer of the Year jury, I have to say that such a strong statement is not the primary purpose of the jury's work. You can take the position I outline above, or you can take an alternative view. In choosing the 100 images, our responsibilities were a little different. You can expect more and less from this portfolio as a result.

Our task begins and ends with the photography. This makes the work both simpler and more difficult than a call to action around the issues raised by the images. We select according to categories, through which we endeavour to represent a range of subjects that reflect the natural world. Within this structure, we look for the 'best' photography, not the most pressing or newsworthy story. When seeking to identify the elusive 'best', we look for original imagery that is done with artistic and technical excellence. We cannot be led by pictures that might make headlines or iconic species that sell books. We are given the mysterious and truly demanding task, one made for long argument, of finding the images that take wildlife photography forward. They need to be pictures that combine great art and craft with relevance and topicality.

It's a mission impossible to get everything right for everybody, with every image. In the movies, Tom Cruise and his *Mission Impossible* chums have it easier, at least in the sense that most of their critics are, by the end, removed from being able to comment. For us, every year tends to mean there are more viewers, and more photographers, with opinions on the selection. If it inspires more debate and a quest for higher standards, then I am pleased.

We do not seek images that are overtly artful, though. The artistry in these pages is a by-product. It comes from the persistence and talent of photographers with a mission to capture amazing moments in the natural world, moments in the life of species and places that have never before been seen quite like this. The artistry is their vision and skill at the service of the content. The result is a book of wonders... and sometimes horror. And what that can do, to answer my question above, is up to you. You may pick up a camera. You may travel. You may have fresh dreams, hopes – and fears – to attend to. You may have a mission.

Lewis Blackwell
Chair of the jury, Wildlife Photographer of the Year 2017

The Competition

To be placed in this competition is to be judged as being among the best of the best – an achievement that wildlife photographers worldwide aspire to. In fact, over the competition's more-than-50-year history, most of the world's leading wildlife photographers have at one time or another been awarded in it, and exposure as a Wildlife Photographer of the Year winner has been the incentive for many a young photographer to turn a passion into a career.

Though there are substantial cash awards, the rewards go beyond the financial. Each year's collection travels the world as a major exhibition and is publicized through a huge range of media.

The result is that it is seen by an audience of more than 50 million. So not only are photographic skill and aesthetic prowess showcased, but a picture with a powerful message will get maximum exposure.

Any photographer, whether professional or not, can submit pictures to this annual competition. The 14 categories exist to give full range to both the many subjects encompassed by natural history and the various styles of photography. There are also three age categories for young photographers, whose pictures are given prominence equal to those of the adult winners. This year, entries numbered nearly 49,000 from more than 90 countries, and 30 nationalities are represented in the final 100 photographs.

With such a large entry, judging has to take place over a number of weeks. It is conducted by an international jury, and at this stage, neither the entrants' names nor the full backstories to the pictures are known. (The stories you read in this portfolio are gathered after the winners have been chosen.) What the judges look for are artistry and new ways of seeing nature – pictures that are arresting, thought-provoking or just beautiful in their simplicity and which remain memorable however many times they are viewed. But unlike most other competitions, great emphasis is placed on subjects being wild and free and on truth to nature, which extends to the strict rules on digital manipulation and processing adjustments.

What the winners tend to share in common is a love of nature that goes beyond personal photographic goals. Indeed, the award ceremony at London's Natural History Museum becomes a gathering of an international community of people who care deeply about the conservation and welfare of wildlife and the importance of the natural world.

The next competition opens on 23 October and closes on 14 December 2017. For the categories and rules, see www.wildlifephotographeroftheyear.com

Judges

Daniel Beltrá (Spain/USA), photographer

Jasper Doest (The Netherlands), wildlife photographer

Britta Jaschinski (Germany), wildlife photojournalist

Rosamund 'Roz' Kidman Cox (UK), writer and editor

Mattias Klum (Sweden), photographer and film-maker

CHAIR
Lewis Blackwell (UK), author and creative director

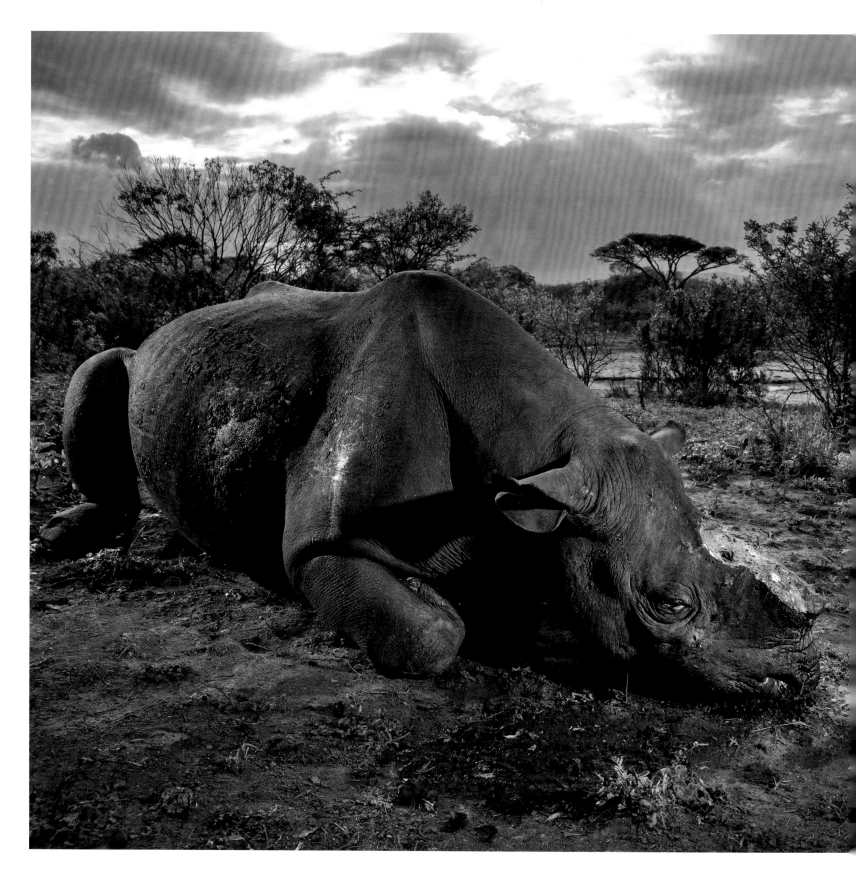

The Wildlife Photographer of the Year 2017

The Wildlife Photographer of the Year 2017 is **Brent Stirton**, whose picture has been chosen as the most striking and memorable of all the entries in the competition.

Brent Stirton

SOUTH AFRICA

A senior correspondent for Verbatim and Getty Images, Brent Stirton shoots mainly for *National Geographic* magazine. He also works regularly for Human Rights Watch, *The New York Times* Magazine, *Le Figaro* and *GEO* magazine, and is a long-time photographer for WWF. He chooses to tell stories about 'issues that matter', focusing on wildlife and conservation, global health, diminishing cultures and sustainability. He has won this competition's photojournalism award four times, along with many other international awards, including nine from the World Press Photo Foundation and 10 Pictures of the Year Awards for his long-term investigative projects.

WINNER

Memorial to a species

A black rhino bull lies dead in South Africa's Hluhluwe Imfolozi Park, shot less than eight hours earlier. Its killers ambushed it at a waterhole, shooting the bull with a hunting rifle fitted with a silencer, and then hacked off its horns. An autopsy revealed that the bullet went through the rhino, causing massive tissue damage, but didn't kill it. The bull ran a short distance, fell to its knees and was then shot in the head from close range. It's a picture symbolic of the decimation of rhino populations throughout Africa, taken as part of an often-undercover investigation into the recent dramatic increase in the illegal trade in rhino horn. Black rhinos were once the most numerous of the world's rhino species. Today, they are critically endangered, with possibly as few as 4,000 remaining in the wild.

Canon EOS-1DX + 28mm f2.8 lens; 1/250 sec at f9; ISO 200; flash.

Wildlife Photographer Portfolio Award

Thomas P Peschak
GERMANY/SOUTH AFRICA

REALM OF THE SEYCHELLES

From the moment he was given his first snorkel and fins, aged six, Thomas Peschak had his head in the water. No surprise then that his first visit to the remote Seychelles archipelago at 14 years old sparked a lifelong love affair with these 115 Indian Ocean islands. He trained as a marine biologist and then became a full-time photojournalist, believing that he could have a greater conservation impact with his photographs than his statistics. An assignment photographer for *National Geographic* magazine, Thomas specializes in conservation stories focused on oceans, coasts and islands.

Here come the snappers

Bohar snappers are among Aldabra's top predators – with the teeth to prove it. As the tide races into the huge lagoon of this Seychelles atoll, they crowd together in the channels that link it with the ocean, eager to catch the influx of smaller fish and invertebrates. Thomas's attempts to swim against the current were futile, and drifting with it gave him just a few minutes with the snappers. Luckily, he was working with scientists, who used baited underwater video cameras to survey sharks. Long before any sharks turned up, the inquisitive snappers went to investigate. 'I wrapped one leg around the steel cable anchoring a survey camera,' explains Thomas. He then used one hand to take pictures, while the other repelled snappers fascinated by his shiny underwater camera housing. Such is their boldness that these fish are easily caught by hook and line, and elsewhere in the western Indian Ocean, the species has been greatly depleted. It took hundreds of frames to get such a compelling split-level shot, capturing the dynamic water line with light bouncing off the surface and the arc of white clouds above, while balancing the colourful fish underneath.

Nikon D2X + 10.5mm f2.8 lens; 1/160 sec at f18; ISO 200; Subal housing; two Inon strobes.

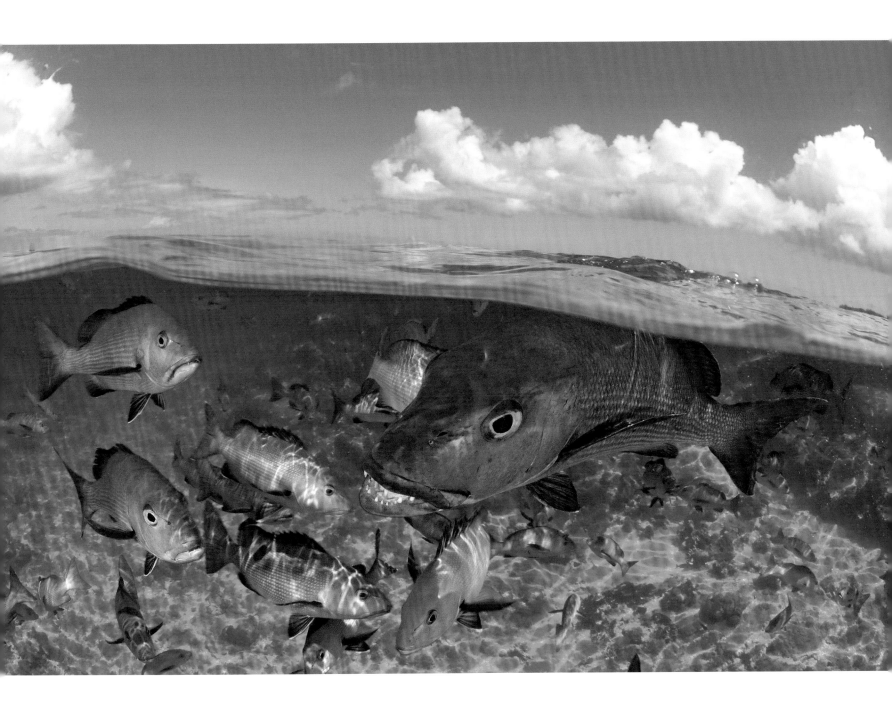

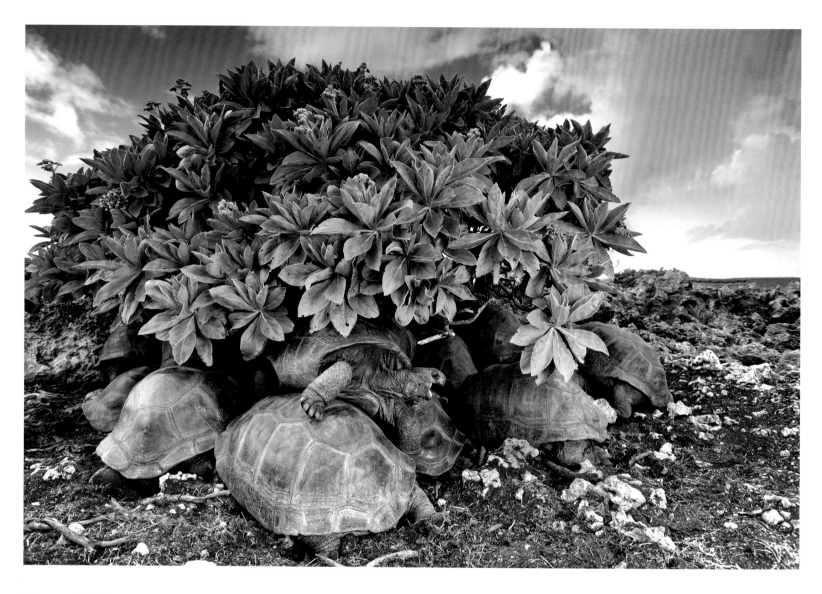

Tree of life

To avoid hyperthermia – effectively cooking to death in their shells – Aldabra giant tortoises have to seek out shade before the midday temperatures peak at 43°C (109°F). Competition is fierce for a place under one of the few stunted trees on this inhospitable Seychelles atoll – there are not many other options when your thick shell stretches more than a metre (3 feet) long, though some hide in caves (the only tortoises known to do this). Giant tortoises – heavily exploited for food by sailors on passing ships – were driven to the brink of extinction in the Indian Ocean by the mid-1800s. A few persisted only on this remote atoll, and appeals for their protection (including by Charles Darwin in 1874) have led to the current population of about 100,000. Thomas used a low wide-angle to capture the restless siesta. 'There was constant jostling and shell-pushing to secure the coolest spots,' he says.

Nikon D3S + 17–35mm f2.8 lens + graduated filters; 1/250 sec at f6.3; ISO 500; flash.

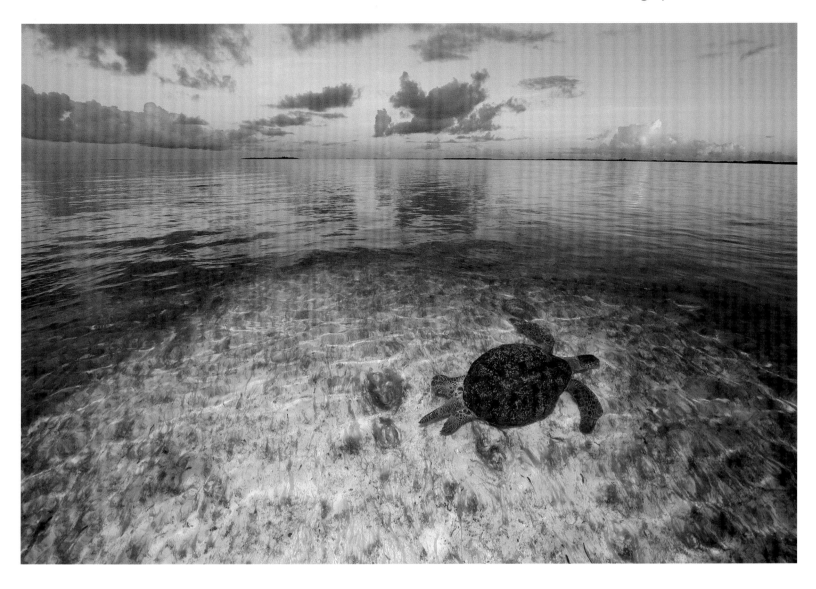

Green haven

Aldabra is a haven for one of the most important populations of endangered green turtles in the Indian Ocean. Every high tide, the expansive seagrass beds in the atoll's lagoon attract a multitude of these grazing reptiles. Unlike other sea turtles, the adults are almost exclusively herbivorous. They can reach 1.5 metres (5 feet) long and take up to 40 years to become reproductively mature – longer than any other sea turtles. They migrate vast distances to return to the same nesting beaches every few years. Widely overexploited for their meat and eggs, green turtles (named after the colour of their fat) are now protected by a raft of international legislation. This has reduced direct harvesting, but other threats include fisheries bycatch, degradation of nesting and foraging sites and disease. Thomas waited weeks for a still evening with high tide around sunset to capture the turtle's iconic shape through the glassy water.

Nikon D3 + 14–24mm f2.8 lens at 14mm; 1/250 sec at f7.1; ISO 400; Nikon SB-800 flash.

The night shift

In the heat of the day, they cluster in the crooks of branches, among tree roots or in the leaf-litter or hide in crevices, but at dusk they come alive. Endangered Seychelles giant millipedes are the cleaners-in-chief of the forest floor, consuming decaying leaves in bulk. These finger-thick, 15-centimetre (6-inch) long invertebrates occur on only 14 small islands in the Seychelles. When brown rats reached Frégate in the mid-1990s, it was feared that the millipedes would be driven to extinction as the hungry rat population expanded. An international response restored the island to a rodent-free sanctuary and established a back-up millipede population in captivity. But now climate change resulting in longer dry seasons is favouring a parasitic fly that kills adult millipedes. And on other islands, invasive plant species such as cinnamon are damaging their habitat – the millipedes prefer eating native leaf-litter, perhaps because it contains more moisture. So far numbers are holding up, but the threats persist for these glossy stars of forest recycling.

Nikon D3S + 20mm f2.8 lens; 1/5 sec at f20; ISO 2000; SB-800 flash.

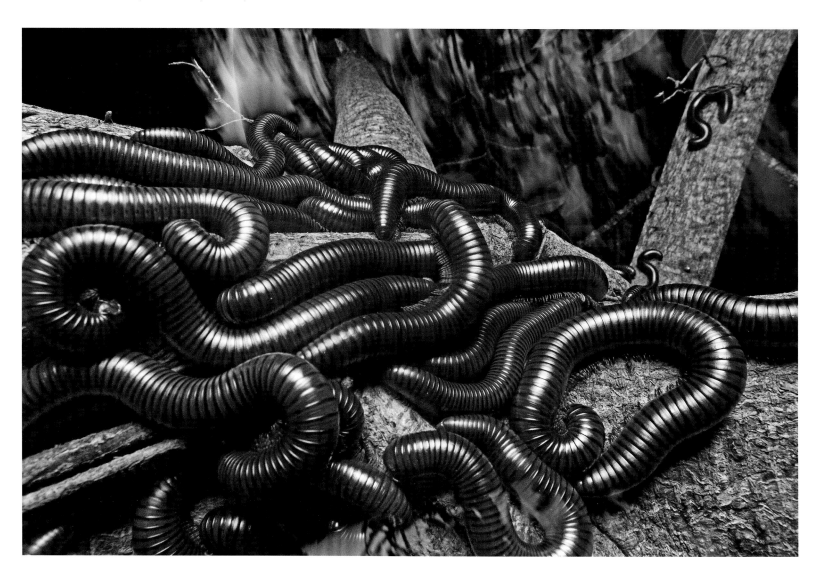

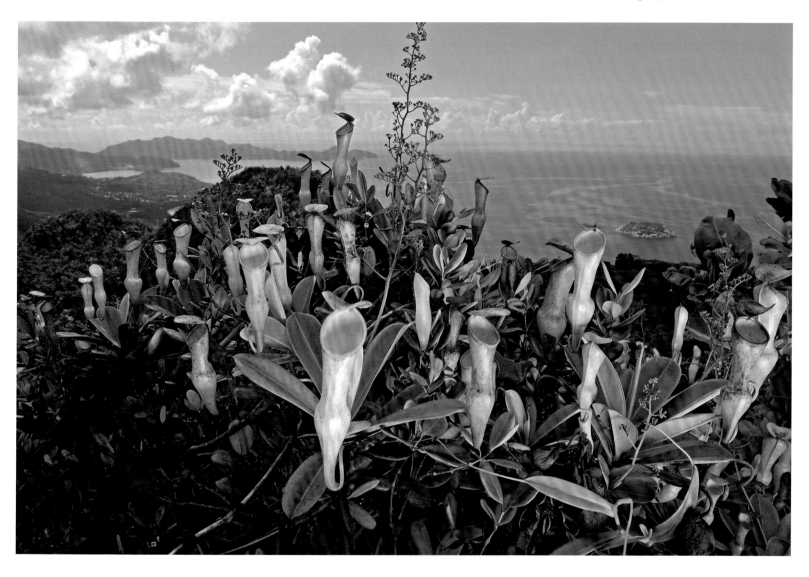

Goblets of desire

A carnivorous diet can make perfect sense for a plant growing on nutrient-poor soil, as this pitcher plant is. It's a species that is found only on the summits of two granite islands in the Seychelles, Mahé and Silhouette, and feeds on insects that get trapped in its liquid-filled carafes. This clump was at the edge of a cliff, entwined in the crown of a bois rouge tree – another plant found only in the Seychelles. 'I had to lean a ladder against my assistant,' says Thomas, 'who was all that stood between me and a tumble down the mountainside.' The midrib of each leathery leaf extends into either a tendril or a pitcher up to 21 centimetres (8 inches) long. Insects lured by the pitcher's sweet smell, colourful lid and nectar-containing rim, lose their grip on its waxy inner wall and slide helplessly into the acidic fluid below, to be digested by enzymes. Not all dinner guests succumb – a mosquito has evolved to lay its eggs only in these pitchers, which may also harbour hundreds of microscopic mites.

Nikon D3S + 24–70mm f2.8 lens at 24mm; 1/200 sec at f14; ISO 200; SB-800 flash.

Before the tide turned

Picture a time before overfishing, development and pollution, and you may well find yourself here. Aldabra atoll in the Seychelles is extremely remote, protected and teeming with life. The lagoon – 30 kilometres (19 miles) long and 10 kilometres (6 miles) wide – is fringed with raised coral on what was once the rim of a volcano. Lounging in its ankle-deep water, an abundance of blacktip reef sharks wait for the tide to come in. With bellies touching the sand, black-tipped fins in the air, they point their snouts into the current to keep oxygenated water flowing over their gills. These powerful swimmers specialize in hunting small fish and invertebrates in very shallow waters over coral reefs. They are viviparous – the embryos develop inside the mother for about 11 months, and she gives birth to up to four pups. To get a higher perspective that included as many sharks as possible and waves breaking on the horizon, Thomas stood on a ladder in the shallows – for many hours, day after day – until the sharks lined up perfectly, with distant storm clouds adding a final touch to conjure the primordial scene.

Nikon D3S + 17–35mm f2.8 lens + graduated filters; 1/200 sec at f10; ISO 500.

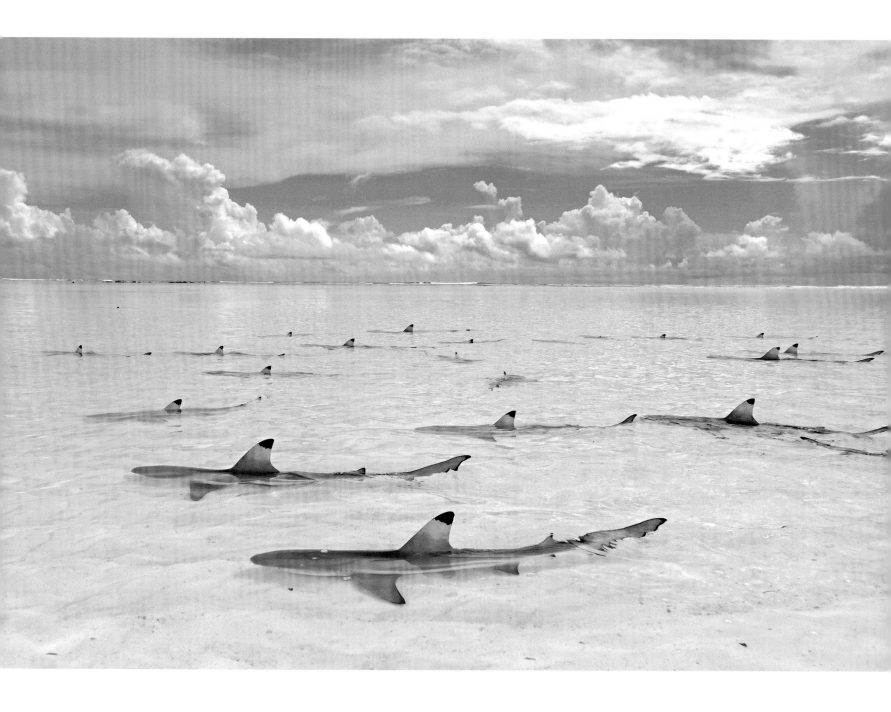

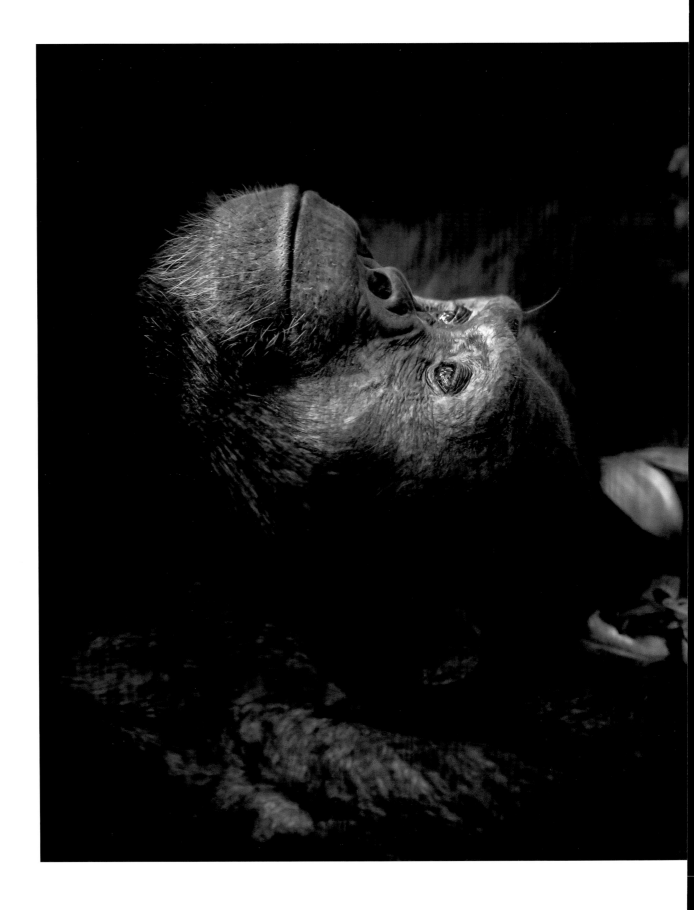

Animal Portraits

Contemplation
Peter Delaney
IRELAND/SOUTH AFRICA

Totti couldn't have tried harder. For more than an hour, he posed, gestured and called to entice one particular female down from the canopy, but nothing worked. The object of his desire ignored him. Peter, too, was frustrated. He had spent a long, difficult morning tracking the chimpanzees – part of a troop of some 250 – through Uganda's Kibale National Park. It was humid, the ground was wet and the dense undergrowth meant that, whenever he did catch up with the chimpanzees, all he got was tantalizing glimpses as they swung from tree to tree. 'Photographing in a rainforest with dim light and splashes of sunlight means your exposure settings are forever changing. Keeping my camera at its optimum ISO setting meant low shutter speeds, and as the park authorities don't allow tripods and monopods, getting a sharp image with a hand-held camera was a challenge,' he says. Totti was on the ground at least, but he was busy with vigorous courtship, pacing and gesticulating. It was only when he finally flopped down, worn out with unrequited love, that Peter had his chance. 'He lay back, hands behind his head, and rested for a moment, as if dreaming of what could have been.'

Fujifilm X-T1 + 50–140mm lens at 140mm; 1/75 sec at f2.8 (–1.3 e/v); ISO 3200.

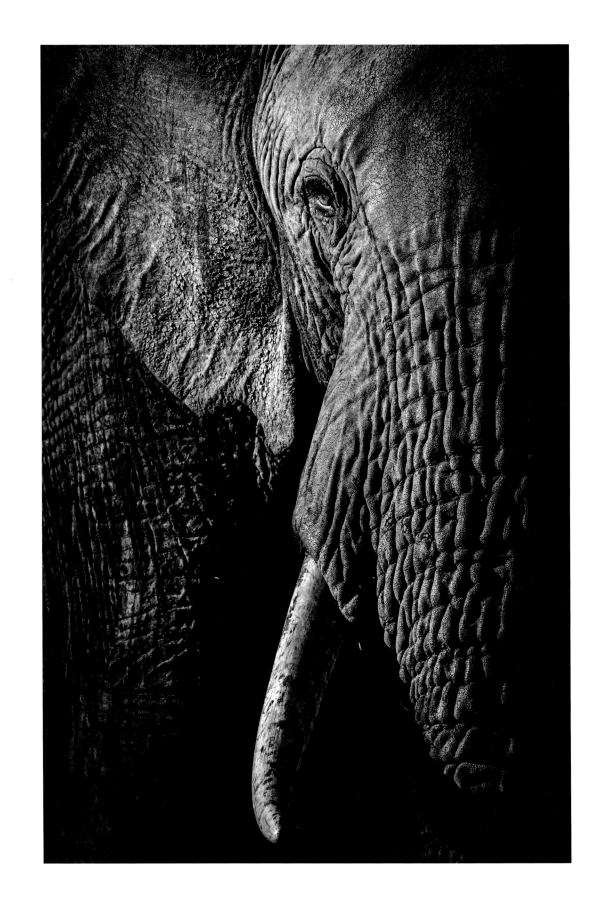

The power of the matriarch
David Lloyd

NEW ZEALAND/UK

At dusk, in Kenya's Maasai Mara National Reserve, David waited for the herd of elephants on their evening trek to a waterhole. As they got closer to his vehicle, he could see that the mellow light from the fast-setting sun was emphasizing every wrinkle and hair. For a photographer who enjoys working with texture, this was a gift. When they were just a few metres away, he could see the different qualities of different parts of their bodies – the deep ridges of their trunks, the mud-caked ears and the patina of dried dirt on their tusks. The elephants ambled by in near silence, peaceful and relaxed. The female leading the dozen-strong herd – probably the matriarch – looked straight at him, her eye a glowing amber dot in the heavy folds of skin. Her gaze was, he says, full of respect and intelligence – the essence of sentience.

Nikon D800E + 400mm f2.8 lens; 1/500 sec at f13 (−0.3 e/v); ISO 1000.

Bold eagle

Klaus Nigge

GERMANY

After several days of constant rain, the bald eagle was soaked to the skin. Named after its conspicuous but fully-feathered white head (bald derives from an old word for white), it is an opportunist, eating various prey – captured, scavenged or stolen – with a preference for fish. At Dutch Harbor on Amaknak Island in Alaska, USA, bald eagles gather to take advantage of the fishing industry's leftovers. Used to people, the birds are bold. 'I lay on my belly on the beach surrounded by eagles,' says Klaus. 'I got to know individuals, and they got to trust me.' The species was declining dramatically until the 1960s, but reduced persecution, habitat protection and a ban on the pesticide DDT has led to its recovery. Some threats persist, including lead poisoning – US prohibition on lead ammunition (which ends up in animals the birds eat) has recently been overturned. 'As the eagle edged nearer, picking up scraps, I lowered my head,' says Klaus, 'looking through the camera to avoid direct eye contact.' It came so close that it towered over him. His low perspective and simple composition, allowing full concentration on the eagle's expression, created an intimate portrait, enhanced by the overcast light of the rainy day.

Nikon D200 + 200–400mm f4 lens + 1.4x extender; 1/80 sec at f10; ISO 500.

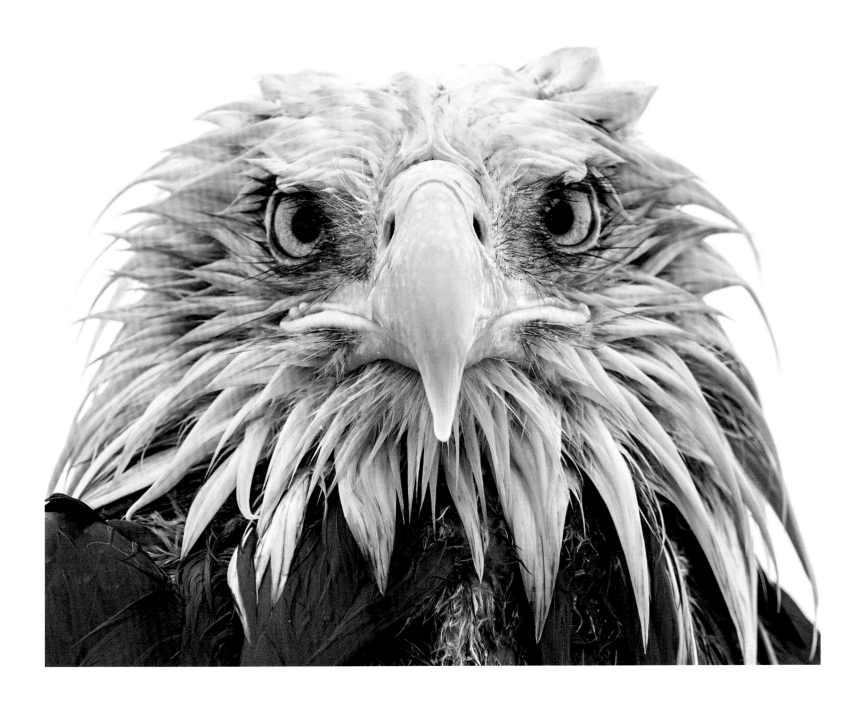

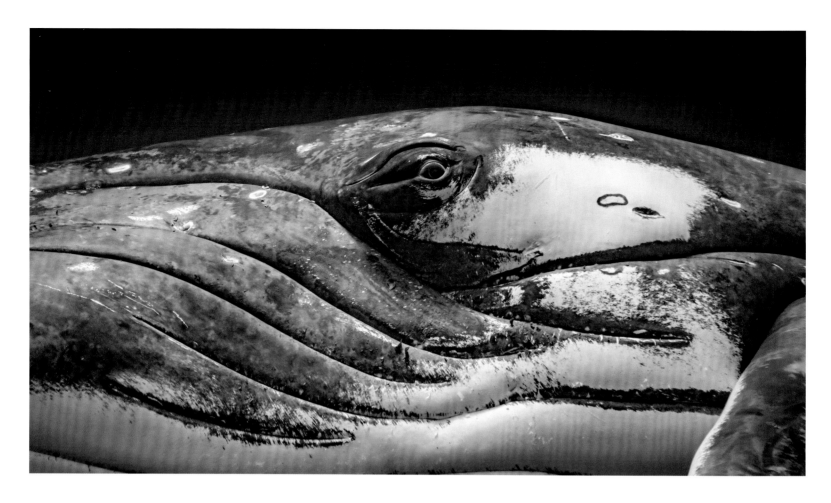

The look of a whale
Wade Hughes

AUSTRALIA

The female humpback whale repeatedly cruised past Wade, each pass slow and measured – once so close that he could have touched her. She was sizing him up to see if he posed any potential risk to her young calf watching him a little way off. Wade was snorkelling off Tonga's Vava'u Islands, a nursery for humpbacks. The females give birth there, and the calves build up their strength and learn to dive, relatively safe from killer whales. Being the subject of her searching, intelligent gaze was, he says, 'humbling', and he knew full well that, despite her great size – some 10 metres (33 feet) long – she was surprisingly agile and capable of defending her calf against any perceived threat. This vigilant mother was part of a group that had migrated north from the Antarctic to overwinter in the warm (but food-poor) Pacific waters. They effectively fast here, but the calves, suckling on their mothers' fat-rich milk, rapidly put on weight. Once the calves are big enough, their mothers lead them on the more than 6,000-kilometre (3,730-mile) journey back south to the Antarctic feeding grounds to feast on krill. 'With a close-up portrait, I wanted to capture something of the intensity of her look and her intelligence,' says Wade. Once she had checked him out and had satisfied herself that he was harmless, she allowed her calf to come closer so that it, too, could satisfy its curiosity.

Canon 5D + 24–105mm f4 lens; 1/250 sec at f8; ISO 400; Nauticam underwater housing.

Toad with attitude
Jaime Culebras

SPAIN

An enormous full moon shone brightly over the Tiputini River in Ecuador's Yasuní National Park, making it easy for Jaime to find his way as he searched for nocturnal wildlife. There was plenty to find: the park is one of the most biodiverse places on Earth, with world records for numbers of species, including more than 150 amphibians. He encountered this highly active smooth-sided (or spotted) toad, one of the biggest in Ecuador, some 15 centimetres (6 inches) long, hopping and clambering along the river bank. He knew that, if threatened, the toad could squirt jets of poison from the parotoid glands on its shoulders (a defence that, until fairly recently, was considered a myth), and he also knew there was no point attempting to photograph it while it was so lively. So he followed the toad until, finally, it stopped right in front of him. It sat upright 'still as a statue', revealing the white spots on its belly – 'like stars' – and giving him time to compose a portrait. Lying prone, Jaime was not only able to place the toad in its moonlit environment but to reflect its size and invincible attitude, 'as if king of the Amazon'.

Canon 6D + Sigma 24mm lens; 30 sec at f4 and f16; ISO 500; two Yongnuo Speedlite flashes; softbox; Manfrotto tripod.

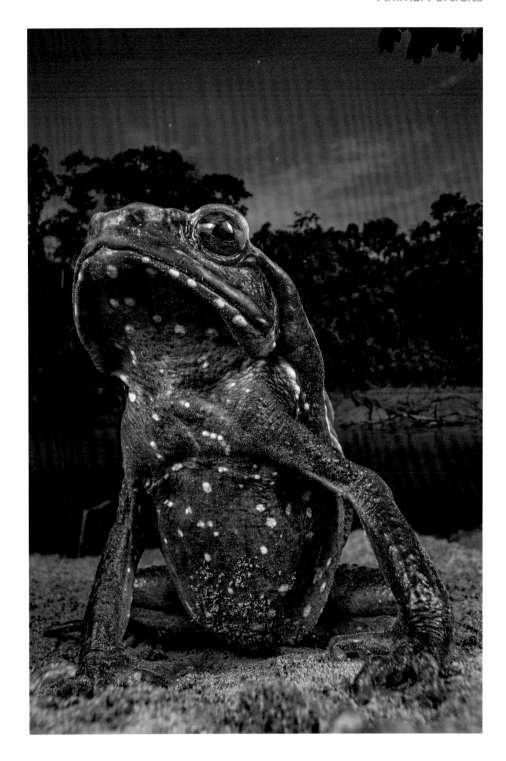

Arctic treasure
Sergey Gorshkov
RUSSIA

Carrying its trophy from a raid on a snow goose nest, an Arctic fox heads for a suitable burial spot. This is June and bonanza time for the foxes of Wrangel Island in the Russian Far East. Lemmings are the basic diet for Arctic foxes, but Wrangel suffers long, harsh winters and is ice-bound for much of the year, making it a permanent source of stored food for these opportunist animals. The food convoys arrive at the end of May. Over just a few days, vast flocks of snow geese descend on the tundra of this remote UNESCO World Heritage Site, travelling from wintering grounds some 4,800 kilometres (3,000 miles) away in British Columbia and California. Not only is this the biggest breeding colony of snow geese in the world, and the only remaining one in Asia, but it is also growing: from 160,000 geese in 2011 to about 300,000 by 2016. The Arctic foxes catch any weak or sick birds, but what they feast on are the goose eggs, laid in early June in open nests on the tundra. Though the pairs of snow geese actively defend their nests, a fox may still manage to steal up to 40 eggs a day, harassing the geese until there's a chance to nip in and grab an egg. Most of the eggs are then cached, buried in shallow holes in the tundra, where the soil stays as cold as a refrigerator. These eggs will remain edible long after the brief Arctic summer is over and the geese have migrated south again. And when the new generation of young foxes begins to explore, they too will benefit from the hidden treasures.

Nikon D300S + 600mm f4 lens; 1/1250 sec at f5; ISO 800; Gitzo tripod + Wimberley head.

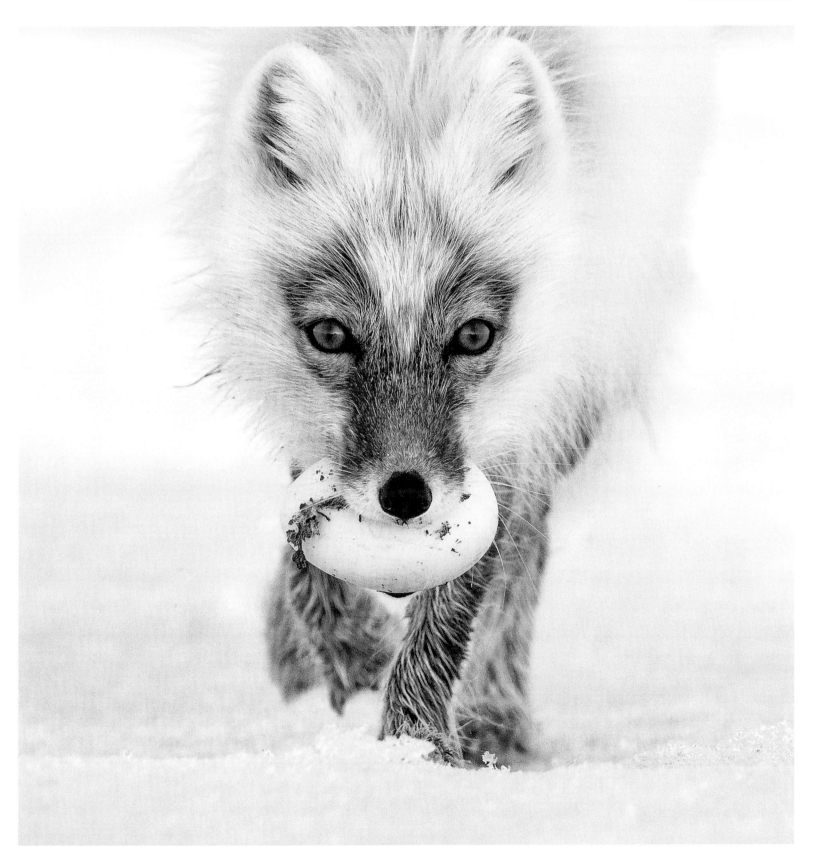

Behaviour: Birds

The incubator bird
Gerry Pearce
UK/AUSTRALIA

Most birds incubate their eggs with their bodies. Not so the Australian brush turkey, one of a handful of birds – the megapodes – that do it with an oven. Only the males oversee incubation. In this case, a male had chosen to create his nest-mound near Gerry's home in Sydney, bordering Garigal National Park. It took a month to build, out of leaves, soil and other debris, at which point it was more than a metre high – mounds used year after year can be more than 4 metres (13 feet) wide and 2 metres (6 feet 7 inches) high. The brush turkey then invited a succession of females to mate with him. If he and his mound were to their liking, they would lay a clutch of eggs in the mound. Always there was a chance that the eggs had been fertilized by a male she had visited previously, and that in a kind of nest-relay, some of his own babies would hatch in another male's mound. As the organic matter in the mound decayed, heat was generated, and to check that the incubation temperature was the necessary 33°C (92°F), the brush turkey regularly stuck his head in and, using heat sensors in his upper bill, checked a mouthful. In this picture, he is piling on more insulation to raise the temperature. If it gets too hot, he will rake it off. Gerry spent four months watching the male and his mound, every day from dawn. After seven weeks, and despite egg raids by a large lace monitor (lizard), at least a quarter of the 20 or so eggs hatched. The big chicks were strong enough to kick (not peck) their way out of their shells and up through the compost heap. Fully independent, they left home straight away to start life on their own in the bush.

Canon 7D Mark II + 18–200mm f3.5 lens; 1/1000 sec at f9; ISO 1600; two Yongnuo Speedlite flashes + wireless trigger.

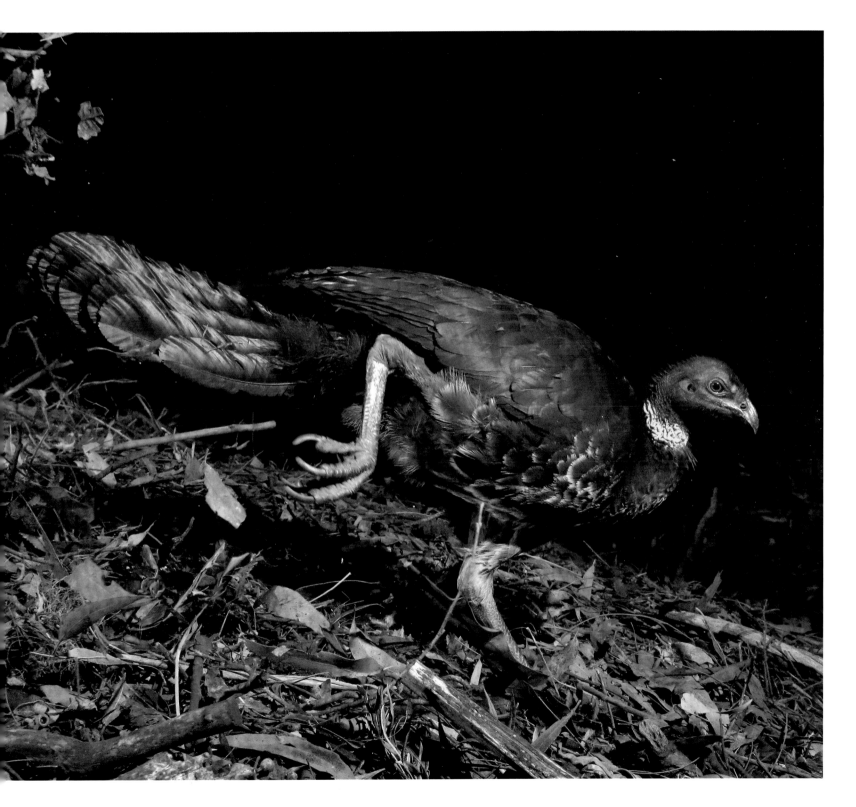

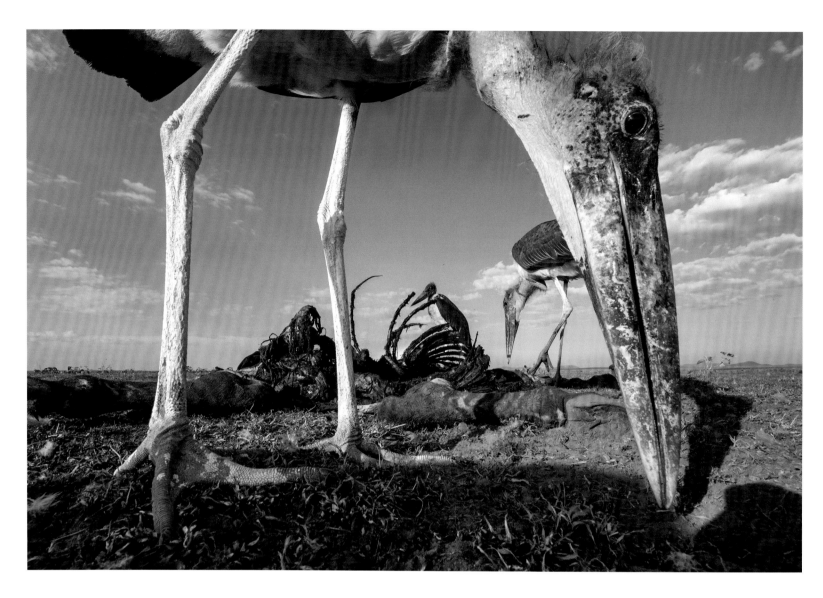

Picky eaters
Daniel Rosengren
SWEDEN

Marabou storks rely on other scavengers to prepare their meals. Their tweezer-like beaks are not designed for ripping flesh but are excellent for picking up morsels – and also, when the opportunity arises, for catching small prey, including insects. Here, in Tanzania's Serengeti National Park, the vultures had already been and gone, leaving plenty of pickings on the zebra carcass. It was migration time for zebras and wildebeest, and the vultures had probably been feasting on more than one corpse and were too full to finish this meal. Daniel had observed the marabou storks waiting for a chance to feed, and as soon as the vultures left, he set up a wide-angle lens for a beak perspective and retreated with a remote control. The storks now could dine free from the normal vulture feeding-frenzy, able to pick away at their leisure – until the arrival of that top-of-the-range scavenger, a hyena, forced them to move on.

Nikon D700 + 14–24mm f2.8 lens; 1/400 sec at f20; ISO 800; Satechi wireless remote.

Breakfast at dawn
Jari Heikkinen

FINLAND

It was just before dawn when Jari arrived at the lake near his home in south Finland. He had been regularly visiting the resident pair of red-throated divers there, watching them and their chick from his floating hide. He knew their routines – several times a day they would proclaim ownership over the territory with a lot of noise and a ritual pair-bonding dance. Before going fishing, they also regularly preened, from a gland at the base of the tail working oil through their feathers to keep them waterproof and in top condition. Jari's attention was on the female preening nearby when the male landed with a splash right in front of the hide, holding the chick's breakfast – a vendace – in its beak. Light bounced off the water, creating an explosion of sparkles that was, Jari says, 'heavenly'.

Nikon D4S + 600mm f4 lens + 1.4x extender; 1/640 sec at f20 (–1.7 e/v); ISO 1600; Manfrotto tripod and video head.

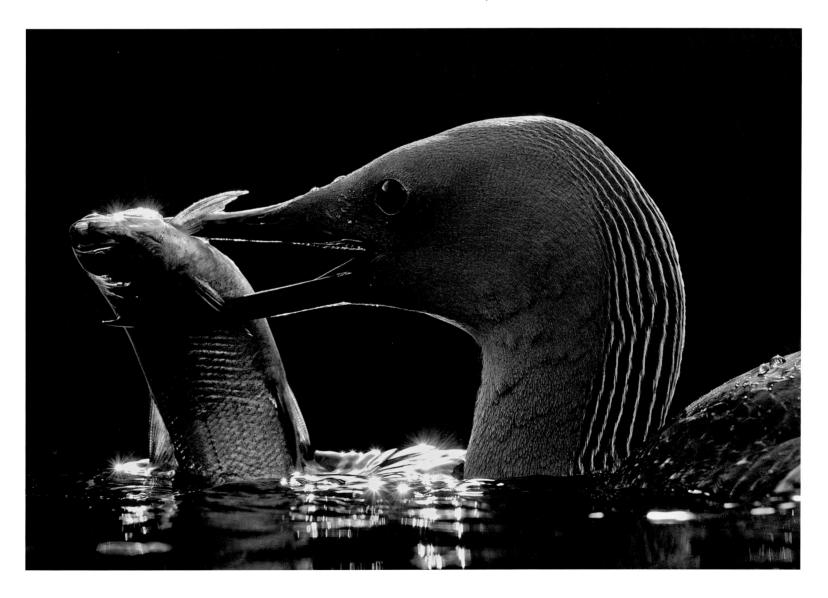

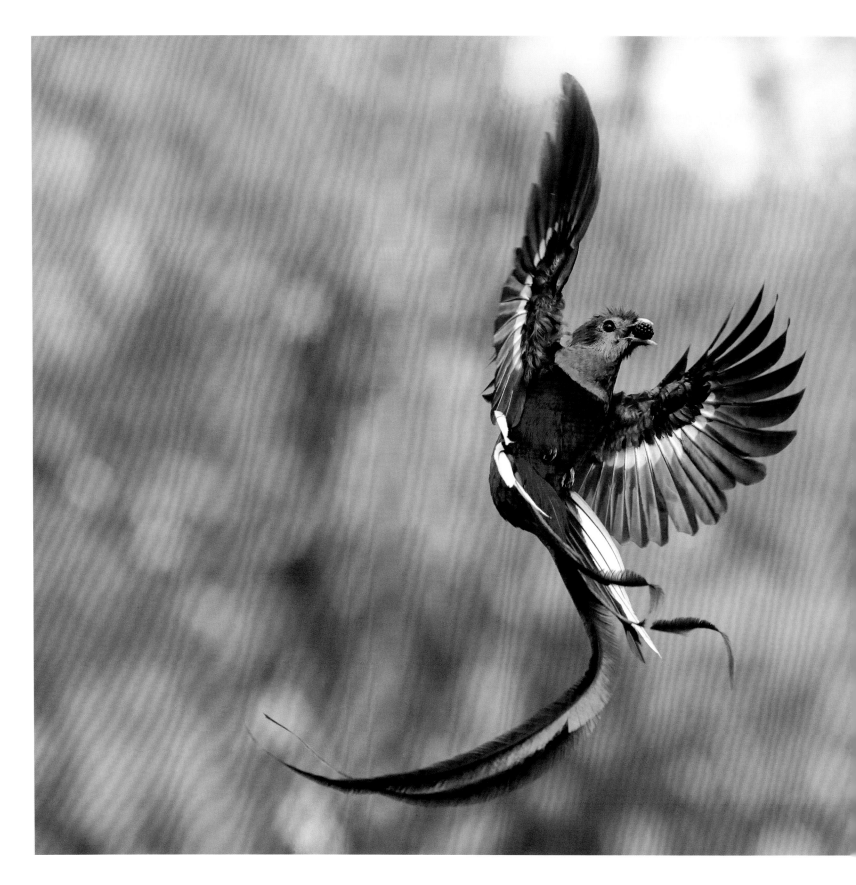

Resplendent delivery
Tyohar Kastiel

ISRAEL

Tyohar watched the pair of resplendent quetzals from dawn to dusk for more than a week as they delivered fruits and the occasional insect or lizard to their two chicks. Resplendent quetzals usually nest in thicker forest, but this pair had picked a tree in a partly logged area in the Costa Rican cloud forest of San Gerardo de Dota. The additional light made it easier for Tyohar to catch the iridescent colour of the male's dazzling emerald and crimson body plumage and tail streamers, despite his fast, erratic flight pattern. But the light also made it easier for the birds to see Tyohar. So he would arrive before dawn, sit in the same place and wear the same jacket, with the result that the pair accepted his presence and continued to stuff food into their chicks' beaks every hour or so. On the eighth day, the parents fed the chicks at dawn as usual but then didn't return for several hours. By 10am, the chicks were calling ravenously, and Tyohar began to worry. Then something wonderful happened. The male arrived with a wild avocado in his beak. He landed on a nearby branch, scanned around, and then flew to the nest. But instead of feeding the chicks, he flew back to his branch, the avocado still in his beak. Within seconds, one chick hopped out to the nearest perch and was rewarded. Moments later the female appeared and did exactly the same thing, and the second chick jumped out. The family then flew off together into the rainforest, leaving Tyohar bereft – and thrilled.

Canon EOS 5D Mark III + 300mm f2.8 lens; 1/3200 sec at f4; ISO 800.

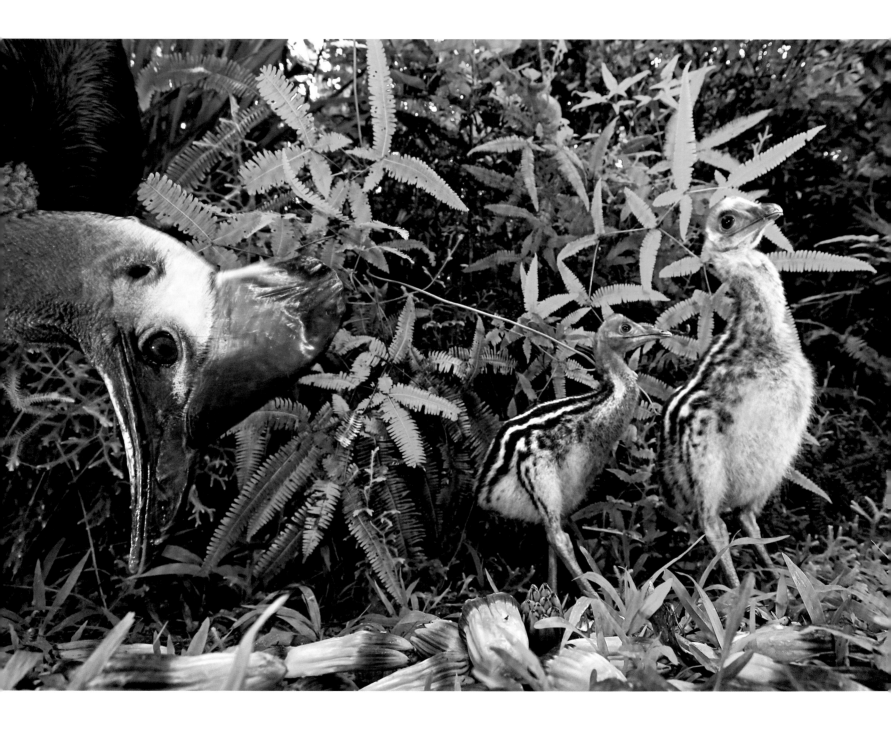

Father knows best
Christian Ziegler

GERMANY

A male southern cassowary shows his six-week-old chicks what to eat. They hesitate to try the segments of fallen pandanus fruit but soon tuck in. Their father will do all the childcare for nine months or more (he also incubated the eggs), teaching the brood what to eat and what dangers to avoid, including poisonous fruits. He is a fearsome protector. Though the casque on his head is most likely a sexual ornament (the female has one, too) and a resonating device for the bird's booming calls and not a weapon, he can deliver a nasty kick with his powerful feet armed with spiked inner toes, and he can run at speed. Indeed, Christian was chased away three times by this territorial male, and the close, low angle of this picture was finally possible only with a camera trap. Despite their size – southern cassowaries can stand up to 1.3–1.7 metres (4¼ –5¾ feet) tall – they are hard to find, living at low densities in the tropical forests of Papua New Guinea, New Guinea and, as here, north Queensland, Australia. With a diet composed almost entirely of fruit, the birds are vitally important dispersers of the seeds of many rainforest trees, acting as the main architects of the forest. But with the forest's destruction and fragmentation, their numbers are also falling. Traffic collisions and dog attacks are also taking a toll, and in Queensland, there may be as few as 1,500 left.

Canon EOS 5D Mark II + 16–40mm f2.8 lens at 16mm; 1/40 sec at f8; ISO 640; three Canon flashes; remote release.

Behaviour: Invertebrates

Crab surprise
Justin Gilligan

AUSTRALIA

Out of the blue, an aggregation of giant spider crabs the size of a football field wandered past. Known to converge in their thousands elsewhere in Australian waters – probably seeking safety in numbers before moulting – such gatherings were unknown in Mercury Passage off the east coast of Tasmania. Justin was busy documenting a University of Tasmania kelp transplant experiment and was taken completely by surprise. A single giant spider crab can be hard to spot – algae and sponges often attach to its shell, providing excellent camouflage – but there was no missing this mass march-past, scavenging whatever food lay in their path on the sandy sea floor. 'About 15 minutes later, I noticed an odd shape in the distance, moving among the writhing crabs,' says Justin. It was a Maori octopus that seemed equally delighted with the unexpected bounty. Though large – the biggest octopus in the southern hemisphere, with muscular arms spanning up to 3 metres (10 feet) and knobbly, white-spotted skin – it was having trouble choosing and catching a crab. Luckily for Justin, the stage was set with clear water and sunlight reflecting off the sand. He quickly adjusted his camera and framed the octopus finally making its catch.

Nikon D810 + 15mm f2.8 lens; 1/100 sec at f14; ISO 400; Nauticam housing; two Ikelite DS161 strobes.

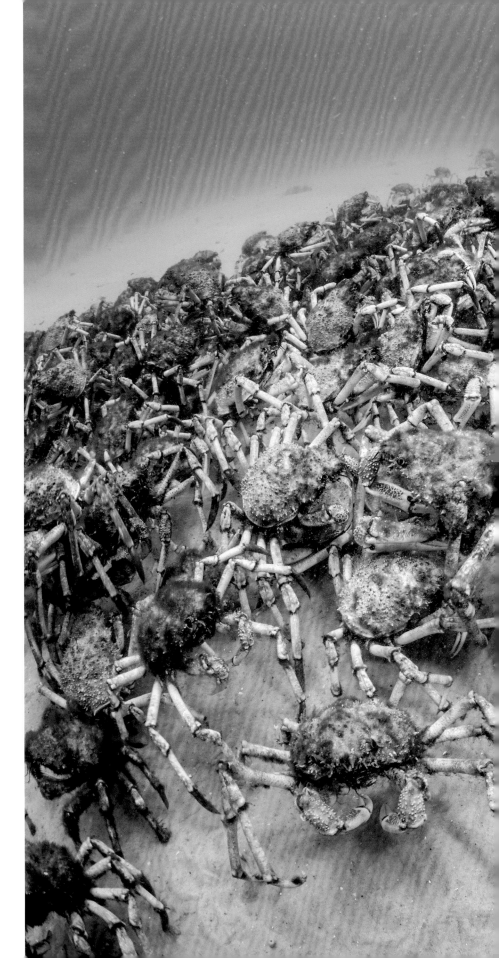

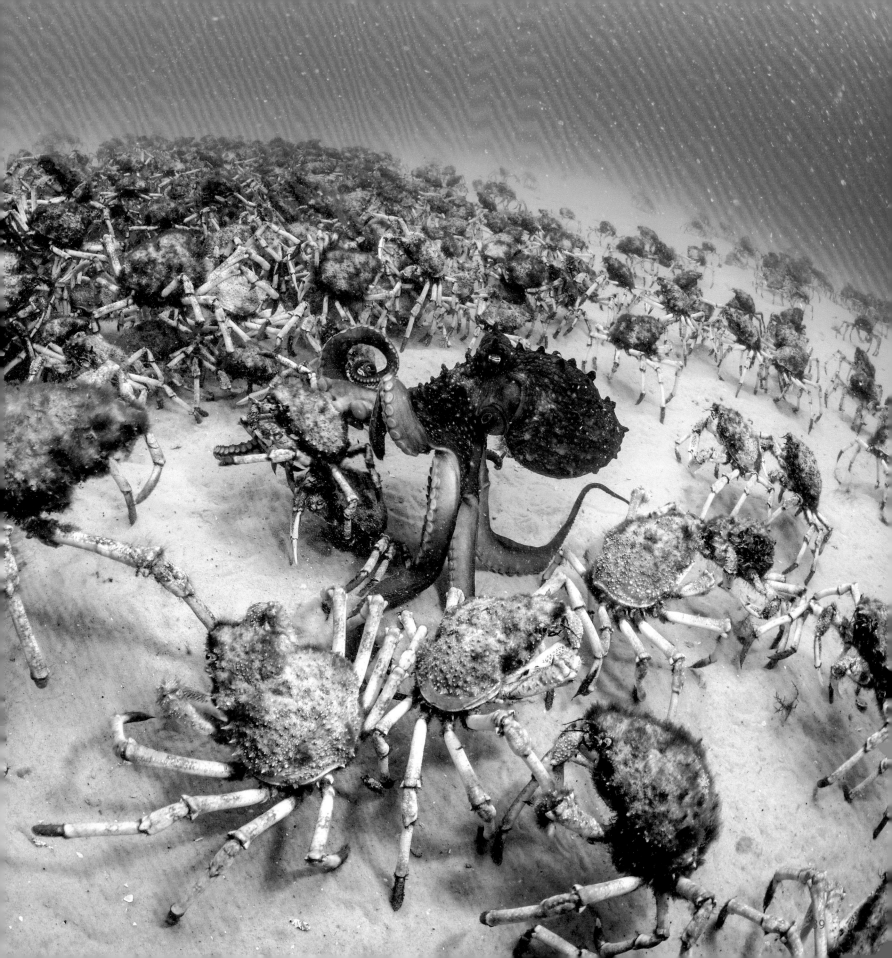

Death by a thousand bites
Lucas Bustamante

ECUADOR

Perhaps the unluckiest place where a newly emerged cicada could happen to be is in the path of an army of ants. But that's where Lucas encountered this one on a night hike in Ecuador's Yasuní National Park, probably the world's most biodiverse rainforest (now threatened by oil extraction and habitat loss). Cicadas spend most of their lives underground (2–17 years, depending on the species). When the nymphs finally emerge, they shed their exoskeletons and inflate their wings with fluid (haemolymph), becoming darker and firmer before starting their brief adult lives looking for mates. 'This one was still so soft and pale,' recalls Lucas. 'It moved only its legs, slowly, in a vain effort to escape.' Amid the chaos of ants – including larger ones with vicious mouthparts, responsible for defending the colony – Lucas composed his shot to tell the dramatic story.

Canon EOS 7D Mark II + 100mm f2.8 lens; 1/250 sec at f20; ISO 100; Speedlite flash; LumiQuest SoftBox.

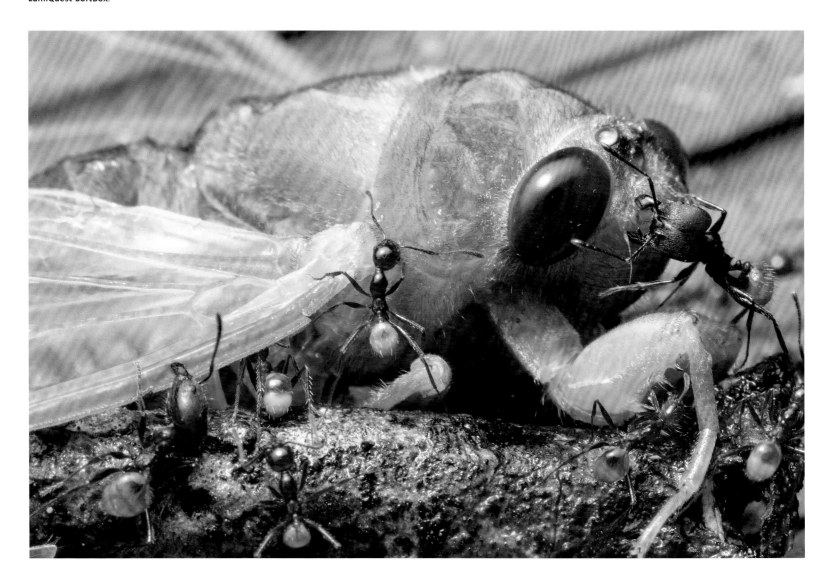

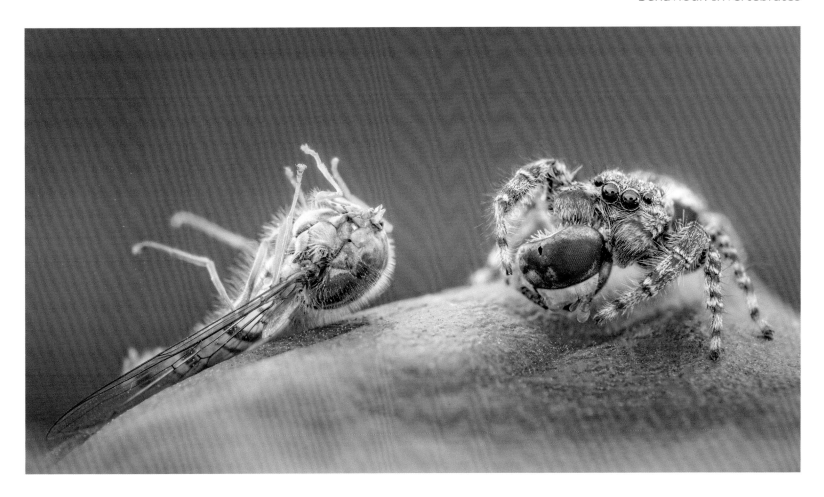

Head hunter
Kutub Uddin

BANGLADESH/UK

Out of the corner of his eye, Kutub caught sight of the spider pouncing from the fence onto the hoverfly. The pair jostled on the leaf-litter for nearly half an hour, until the hoverfly was stilled and the spider began its meal – head first. The scene, as dramatic as any on the Serengeti, took place in West Sussex, UK. The predator, aptly named the fence-post jumper, is one of more than 5,000 species of jumping spiders, renowned for their excellent sight and cat-like hunting skills. It has four front-facing eyes and four on top of its head. The two biggest provide acute vision – with a system of tubes and muscles that allow it to scan a subject and compile a complete picture – while the other six mainly detect movement. This means it can spot prey from afar, creep up and jump on it with great accuracy – pumping its three pairs of rear legs with fluid (haemolymph) so that they suddenly extend for the spring. With the spider settled and eating, Kutub created his picture by taking a series of shots at the same time but focused on different points and 'stacking' (aligning) them to create one focused image. He placed a piece of paper behind to give a clean background to the leaf, the decapitated body and the spider, now holding the sucked-dry head of the hoverfly.

Sony A77 Mark II + 100mm lens + Raynox filter; 1/250 sec at f13; ISO 100; Sony flash.

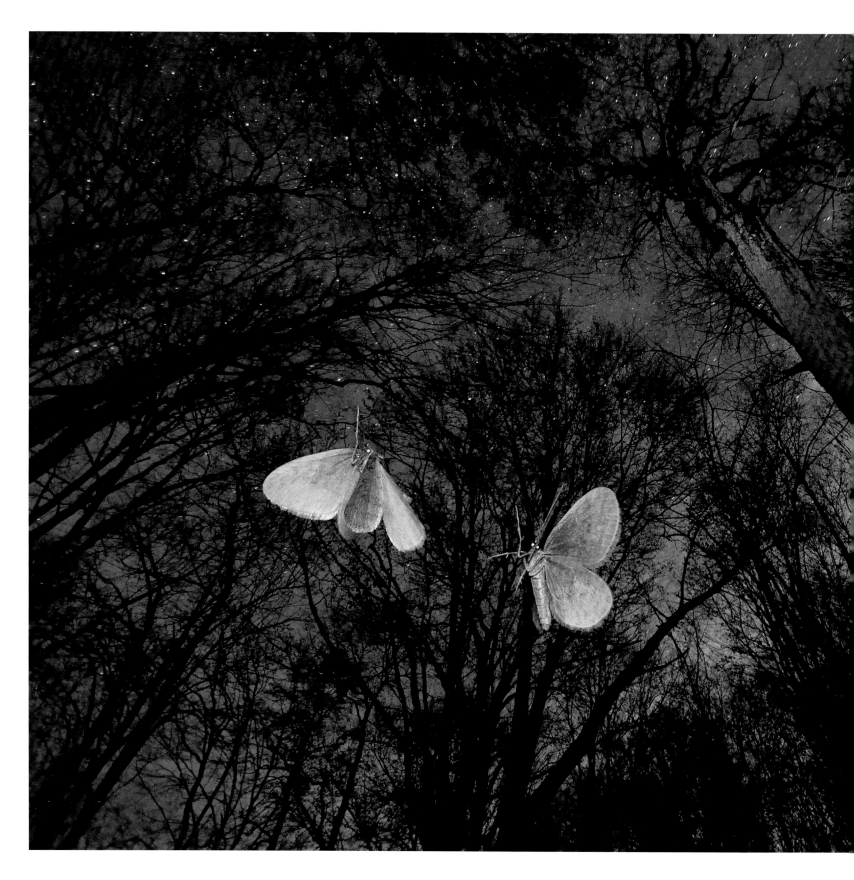

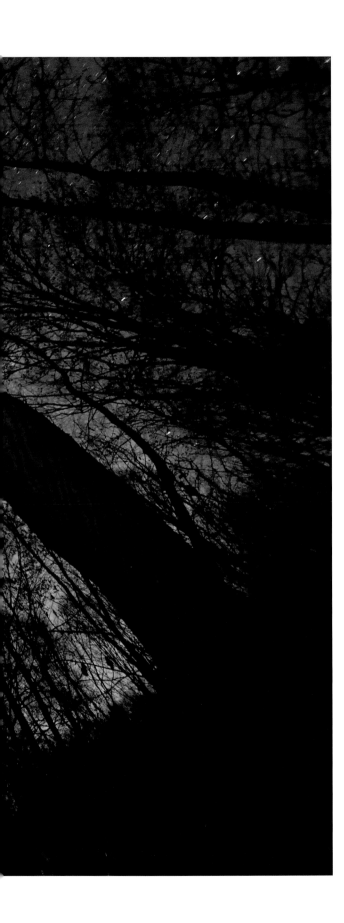

Wings of winter
Imre Potyó
HUNGARY

Flitting through the bare branches of the dark forest, a male winter moth seeks romance under the stars. Imre froze its movement across the frame with multiple bursts of light from a stroboscopic flash. On mild nights, from late October to early January, male winter moths swarm among the trees in the Börzsöny Hills of northern Hungary. Imre used a torch to find them in the dark. 'I was soon covered in moths,' he says. These fragile insects, wings spanning less than 3 centimetres (1¼ inches), won't find love in the air – the grey, wingless females cling to tree trunks, emitting a sex pheromone that often attracts clouds of males. After mating, a female deposits her tiny eggs – as many as 350 – on bark or in crevices. The adults then die, leaving the eggs to overwinter. To capture both the moth's rapid flight and the starlit forest (trees to the right silhouetted by light from a nearby village), Imre used an in-camera double exposure, lighting the moth with flash and firing the shutter again with the focus on the stars. It took very many goes to create this image revealing the moth's night-time pursuit.

Nikon D90 + Nikkor 50mm f1.8 lens + Tamron 10–24mm f3.5–4.5 lens at 11mm; double exposure: 1/15 sec at f13 + 60 sec at f3.5; ISO 1250; flash; Manfrotto tripod + UniqBall head.

Fly killer

Kutub Uddin

BANGLADESH/UK

The golden-tabbed robberfly – a large robberfly, scarce in the UK – had its perch on a leaf in a field in West Sussex. Sitting stock still, it was scanning the sky. An unsuspecting fly flew past several times. As it swept by just that bit too close, the robberfly darted up, grabbed it in mid-air and flew off with it. Kutub managed to locate the attacker's landing place, the fly gripped between its strong, bristly legs. Like other robberflies, this species has a characteristic groove between its prominent compound eyes and a stiff 'moustache' of bristles to protect it from struggling prey. But now the fly was no longer struggling. The robberfly had stabbed it with its short proboscis, injected it with saliva – containing enzymes to paralyze it and digest its insides – and was beginning to suck up the liquefied contents. The meal took more than half an hour. 'It was fascinating to watch,' says Kutub. 'The prey's eyes were red to start with but became yellow as the robberfly sucked.' Kutub's image was created by taking several pictures in quick succession, with different points of focus that he then combined by 'stacking', revealing the dinner and diner in intricate detail.

Sony A77 Mark II + 100mm lens + Raynox filter; 1/250 sec at f11; ISO 100; Sony flash + custom-made diffuser.

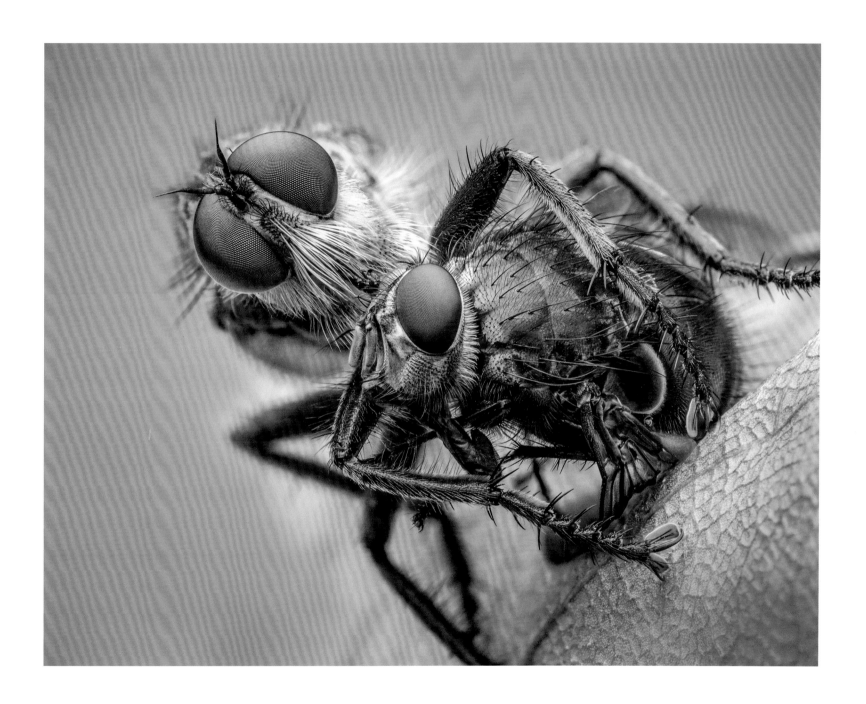

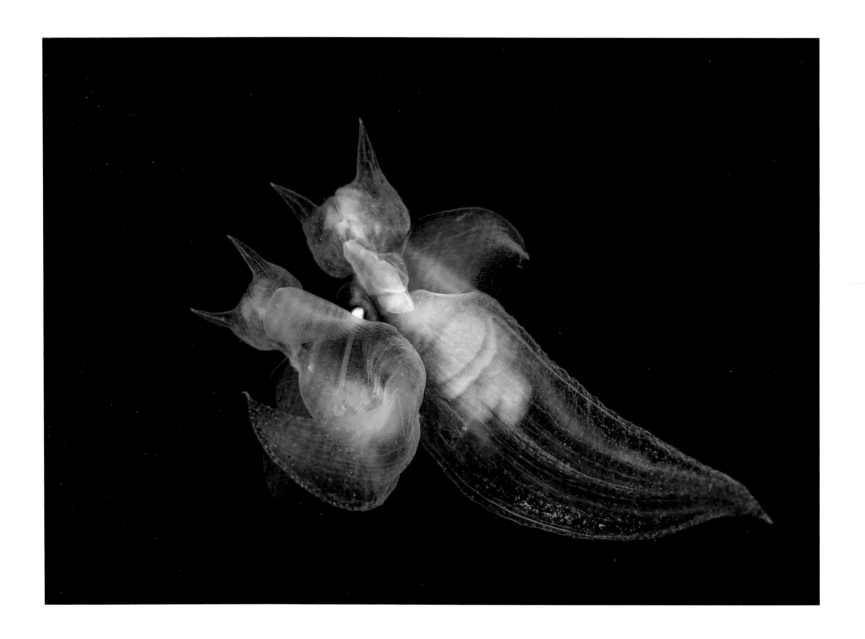

Romance among the angels
Andrey Narchuk
RUSSIA

Andrey was on an expedition to the Sea of Okhotsk in the Russian Far East, and his intention on this day was to photograph salmon. But as soon as he jumped into the water, he found himself surrounded by thousands of mating sea angels. Quickly swapping to his macro equipment, he began photographing the pairs, 3 centimetres (1¼ inches) long and swirling around in the current. Sea angels are molluscs related to slugs and snails, without shells and with wing-like lobes used as swimming paddles. They hunt sea butterflies – swimming sea snails – using specialized feeding parts to prise them from their shells. Each individual is both male and female, and here they are getting ready to insert their copulatory organs into each other to transfer sperm in synchrony. One is slightly smaller than the other, as was the case with most of the couples Andrey observed, and they remained joined for 20 minutes. Both would go on to lay 100 or so tiny eggs after fertilization. It was late summer and peak phytoplankton time, so there would be abundant food for the resulting larvae. To photograph them mating, Andrey had to battle against strong currents and avoid a wall of gill netting, and when he was swept into the net and his equipment became snared, he was forced to make an emergency ascent – but not before he had got his shot. The following day, there wasn't a single angel to be seen.

Canon EOS 5D Mark II + 100mm f2.8 lens; 1/125 sec at f13; ISO 200; Nexus housing; two Inon strobes.

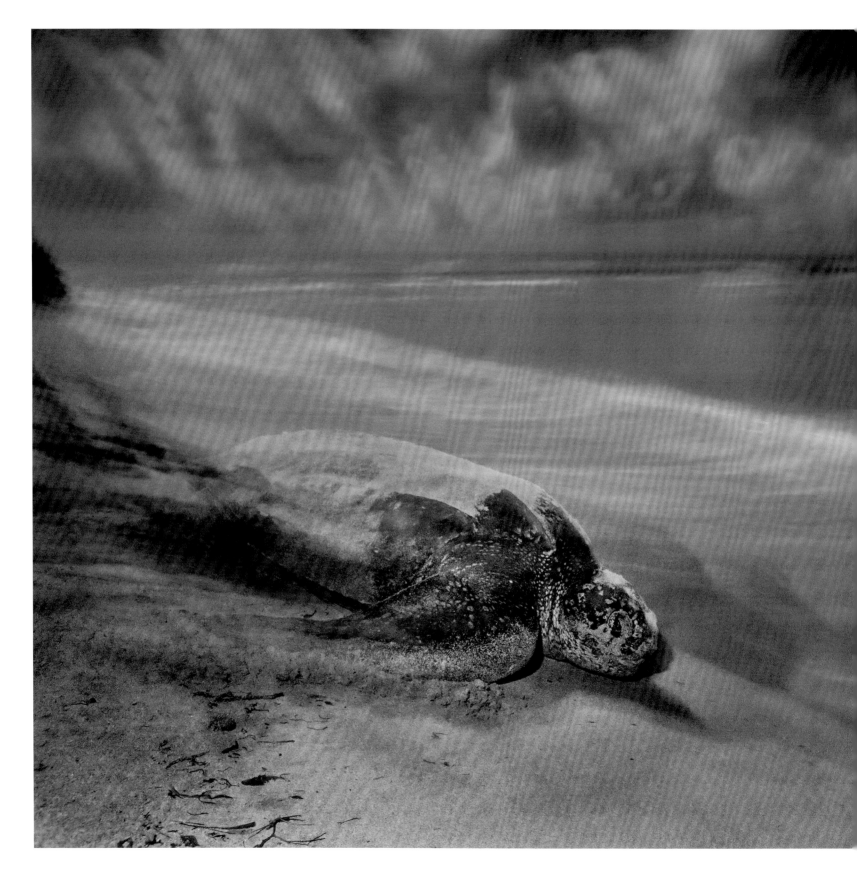

Behaviour: Amphibians and Reptiles

The ancient ritual
Brian Skerry

USA

Like generations before her, the leatherback turtle shifts her considerable weight with her outsized, strong front flippers and moves steadily back to the ocean. Leatherbacks are the largest, deepest-diving and widest-ranging sea turtles, the only survivors of an evolutionary lineage that diverged from other sea turtles 100–150 million years ago. Much of their lives are spent at sea, shrouded in mystery. When mature, their leathery shells now averaging 1.6 metres (5 feet 3 inches) long, females return to the shores where they themselves hatched to lay their own eggs. Sandy Point National Wildlife Refuge on St Croix, in the US Virgin Islands, provides critical nesting habitat, successfully managed for decades. Elsewhere, leatherbacks are not so lucky, threatened primarily by fisheries bycatch as well as factors including human consumption, coastal development and climate change. The females each lay about 100 eggs in nests dug deep in the sand. Some 60 days later, the hatchlings emerge, their sex influenced by incubation temperatures (hotter nests produce more females). Nesting turtles are not seen every night at Sandy Point, and were often too far away for Brian to reach. When after two weeks he got the encounter he wanted – under clear skies, with no distant city lights – he hand-held a long exposure under the full moon, artfully evoking a primordial atmosphere in this timeless scene.

Nikon D5 + 17–35mm f2.8 lens at 24mm; 10 sec at f8; ISO 1600; Nikon flash at 1/64th power + tungsten gel; Nikon remote release.

The gladiator versus the beetle

Javier Aznar González de Rueda

SPAIN

It was a hot, humid night, alive with insects drawn to the lights of the lodge in San Lorenzo, Ecuador. Crowded at the windows for a share of the bounty were geckos and frogs. A treefrog had snared a large weevil, but now the frog was in trouble. Built like a tiny tank, the weevil was gripping the frog's tongue, preventing it from swallowing. Rosenberg's treefrog – a type of gladiator frog, its body about 7 centimetres (2¾ inches) long – is no stranger to aggression. Unlike most frogs, a male has to provide a nest to secure a mate, building one from mud or sand, adopting a hollow or stealing a neighbour's nest. Ensuing fights can be lethal. Javier grabbed his camera and framed his shot – the frog's gold-flecked eyes and skin echoed by the glow through the patterned glass – just before the weevil escaped, as did the frog.

Canon EOS 70D + 8–15mm f4 lens at 15mm; 8 sec at f11; ISO 250; two Yongnuo Speedlite flashes; Manfrotto tripod + UniqBall head.

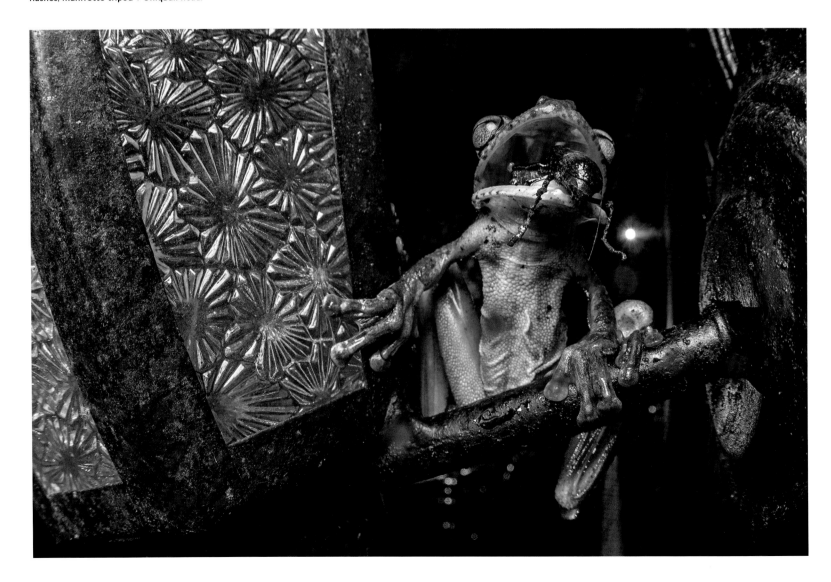

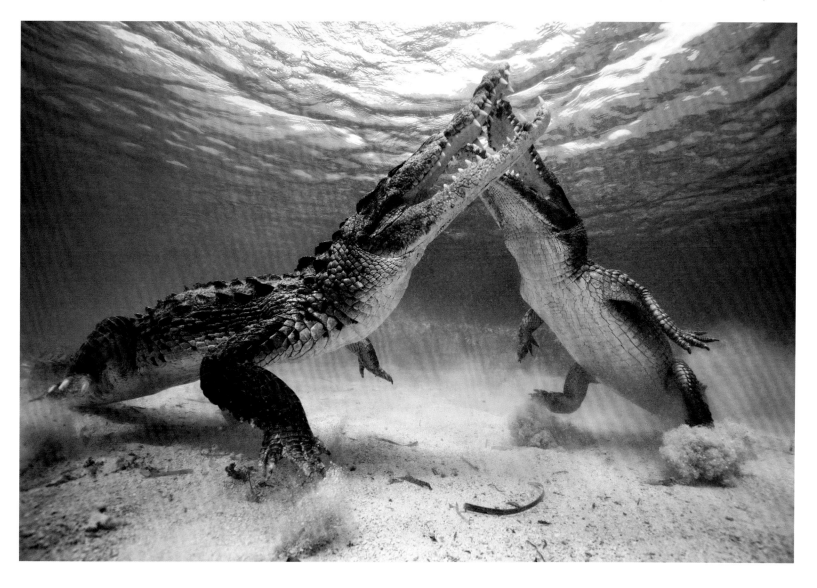

Snap shot

Rodrigo Friscione Wyssmann

MEXICO

In the shallows of Mexico's Chinchorro Bank Biosphere Reserve, two American crocodiles – both about 3 metres (10 feet) long – faced off. Just before the rivals lunged at one another, Rodrigo submerged, holding his breath. Powered by their strong legs and muscular tails, jaws snapping, the crocodiles went for each other's throat and eyes. Though American crocodiles are territorially aggressive, combat under water is rarely witnessed – smaller crocs usually give way to larger ones – and this fight lasted just seconds before the intruder backed down. But lying on the sand with his camera pre-set to shoot into the surface light, his strobes aimed downwards to minimize backscatter (caused by illuminated particles), Rodrigo captured the clash and got the shot he had dreamed of for years.

Nikon D800 + 16–35mm f4 lens at 16mm; 1/250 sec at f6.3; ISO 200; Nauticam housing; two Inon strobes.

Night of the turtles
Ingo Arndt

GERMANY

The greatest arrivals on Costa Rica's Pacific coast occur in the rainy season, often on the darkest nights, a few days before a new moon. Hundreds of thousands of female olive ridley turtles haul themselves up their natal beaches at Ostional National Wildlife Refuge to lay eggs. The exact timing is unpredictable – anticipation builds as the throng of turtles swimming near the shore grows. The turtles have migrated from their open-ocean feeding grounds to mate just offshore. Then, the females drag themselves ashore under cover of darkness, dig nests in the sand and lay clutches of more than 100 eggs. On only one night during Ingo's three-week trip did the elements combine as he had hoped – a mass arrival of turtles in just enough light to capture the spectacle with a very high ISO camera setting. Tracing their paths with a four-second exposure in the dim blue of the night, he portrayed hundreds of turtles slowly and purposefully dragging themselves up the sand.

Canon EOS-1DX + 70–200mm f2.8 lens at 135mm; 4 sec at f16; ISO 12800; Gitzo tripod.

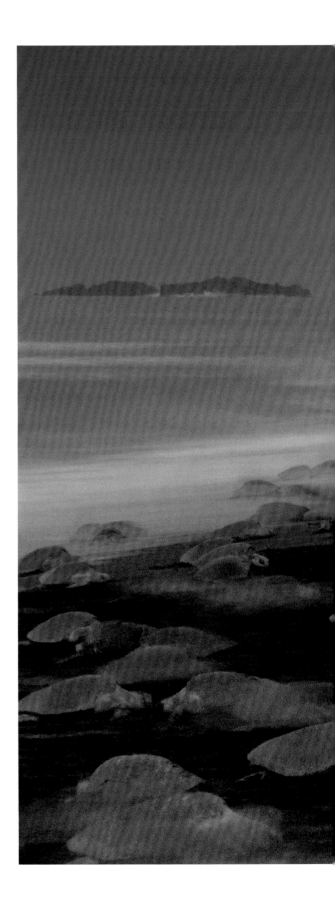

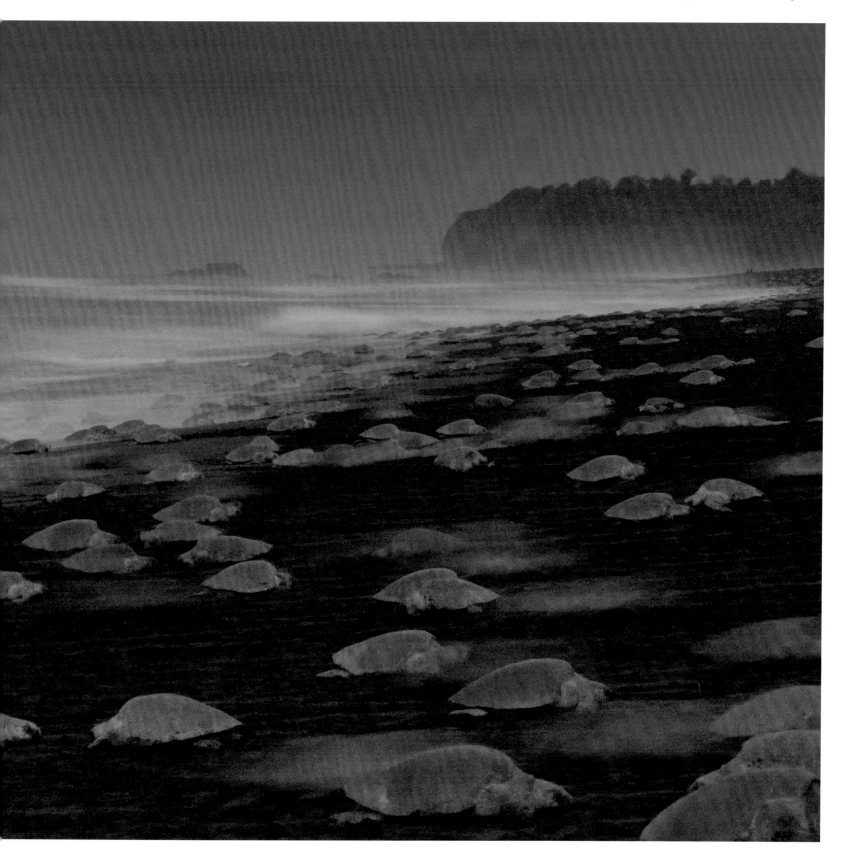

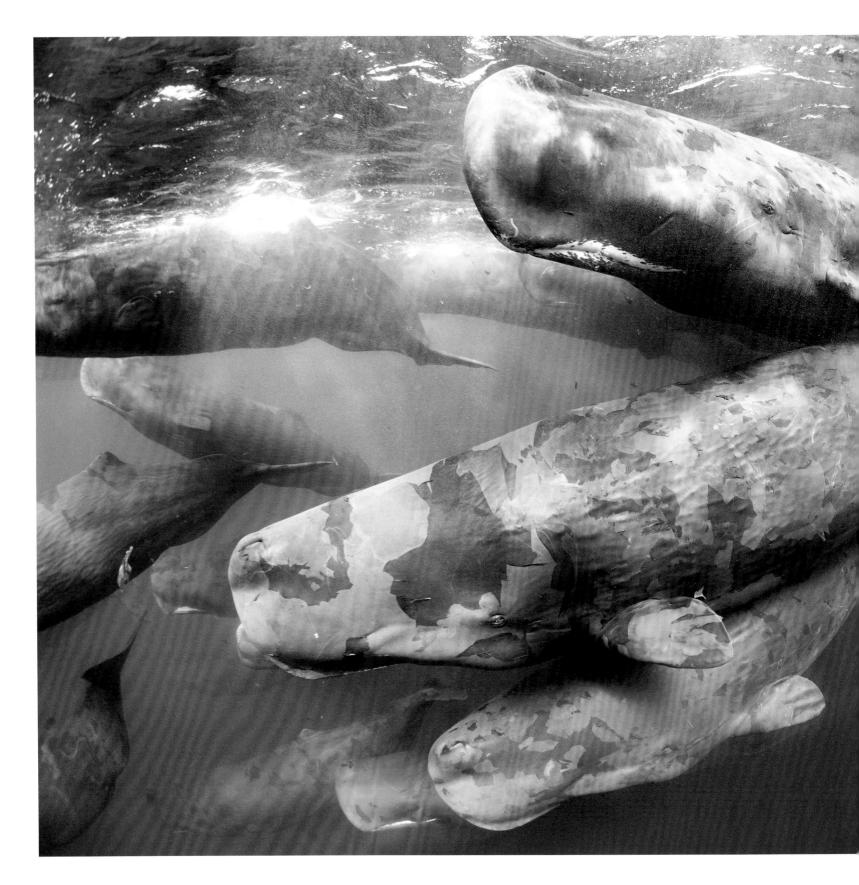

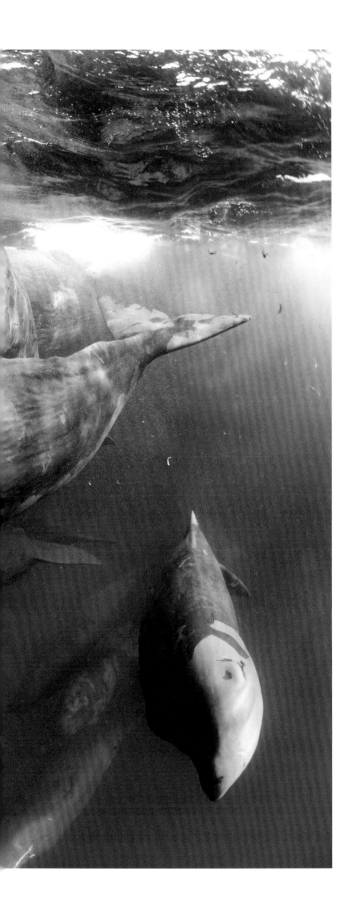

Behaviour: Mammals

Giant gathering
Tony Wu
USA

Dozens of sperm whales mingled noisily off Sri Lanka's northeast coast, stacked as far down as Tony could see. This was part of something special – a congregation of dozens, perhaps hundreds, of social units, like a gathering of the clans. Sperm whales are intelligent, long-lived and gregarious, and groups play, forage, interact and communicate in different ways and have distinctive cultures. Aggregations like this could be a critical part of their rich, social lives but are rarely reported. Some two thirds of the sperm whale population was wiped out during the peak of industrialized whaling in the twentieth century. But commercial whaling was banned in 1986, and this kind of major gathering could be 'a sign that populations are recovering', says Tony, who has spent 17 years studying and photographing sperm whales. Tactile contact is an important part of sperm whale social life, but rubbing against each other also helps slough off dead skin. So the water was filled with a blizzard of skin flakes. More photographically challenging was the smearing of the camera-housing dome with oily secretions from the whales and thick clouds of dung released as they emerged from the gigantic cluster. But through continually swimming to reposition himself and the tolerance of the whales themselves, Tony got a unique photograph of the mysterious Indian Ocean gathering.

Canon EOS 5D Mark III + 15mm f2.8 lens; 1/250 sec at f6.3; ISO 800; Zillion housing + Pro-One optical dome port.

Spring release

John Mullineux

SOUTH AFRICA

Desperate to drink, the impalas edged towards the water. They could see several Nile crocodiles lying in wait at the edges of the dam, ready to launch an attack, but they were very thirsty and had to drink. In normal years, the muddy pool below the dam was part of a river, but after three years of low rainfall, there was precious little water anywhere in South Africa's Kruger National Park. The impalas quickly slaked their thirst, while never taking their eyes off the crocodiles, and John never took his eyes off them: an attack was likely, but it would happen in an instant. Sure enough, one of the crocodiles exploded out of the water, and for the briefest of moments, all four impalas turned towards him as they twisted their bodies away from danger. Just as soon as its jaws shut tight, on nothing, the crocodile retreated into the mud, dug itself down again, its legs and tail in ambush position, and settled back to wait for another opportunity. The next day, the heavens opened and the drought broke, giving the impalas a chance of a safer drinking location and the crocodiles less chance of an easy meal.

Canon EOS-1D Mark IV + 100–400mm f4.5–5.6 lens; 1/2000 sec at f5.6; ISO 400.

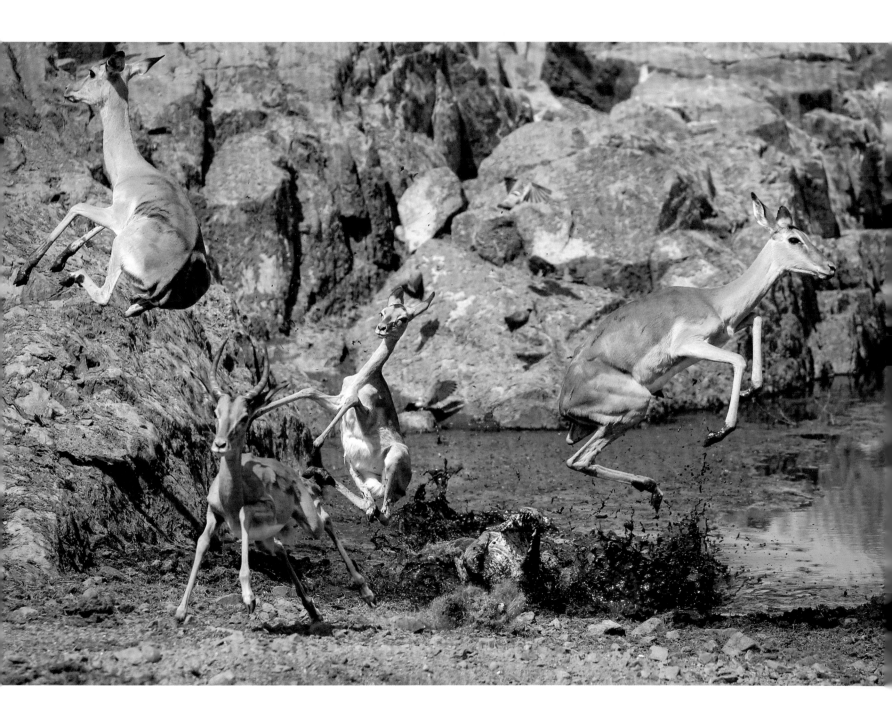

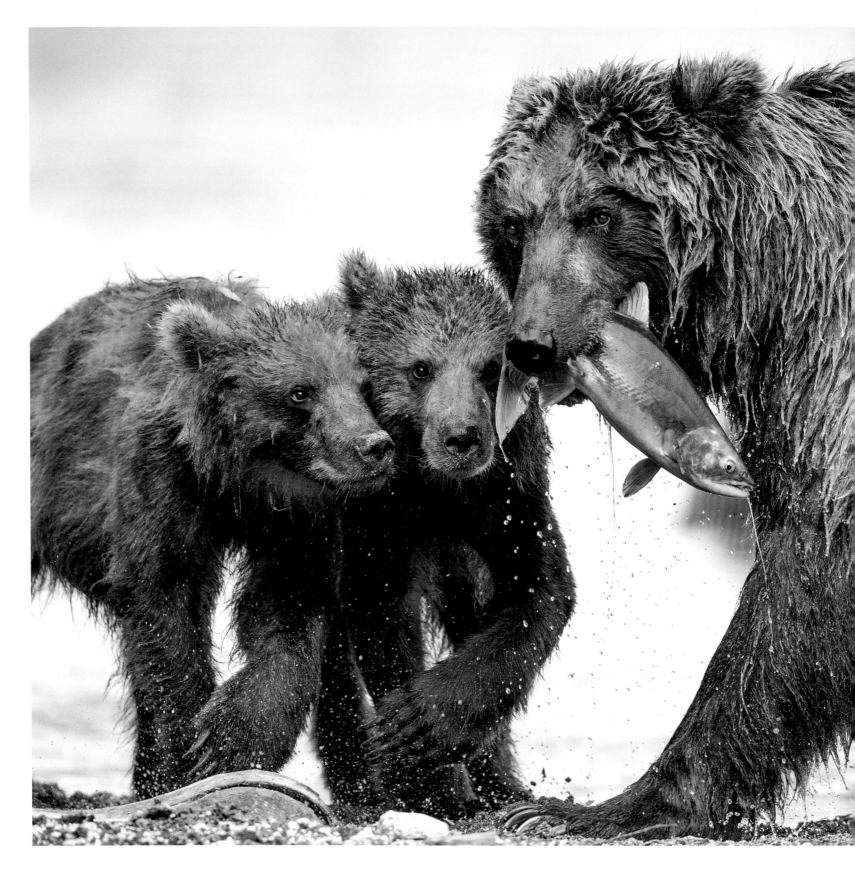

Anticipation
Marco Urso

ITALY

As soon as they saw their mother emerge from the lake carrying a plump sockeye salmon, the cubs rushed towards her. Marco, watching the family from just a few metres away, had anticipated their behaviour. He has been coming to Lake Kuril, in Kamchatka, Russia, every summer since 2013 to watch the brown bears. It is the largest sockeye salmon spawning area in the western Pacific, supporting a population of about 1,000 of the Kamchatka brown bear. Marco spends up to 10 hours a day photographing the bears (he once saw 40 fishing from the shore) and has got to know their different personalities, habits and ways of behaving. These cubs are about 15 months old, and though they can catch weak or dying salmon for themselves, they have much to learn about fishing and are still reliant on the fish their mother catches – an average 20 salmon a day. Shooting at ground-level with a long lens, Marco caught the moment when the twins were facing the camera, eyes fixed on the salmon, paws raised in anticipation of their mother letting them snatch a bite of the catch. In a week or so, at the end of August, when the peak of the salmon season is over, the family will move inland to fish along the creeks. The cubs will stay with their mother over winter and won't be independent until they are at least two years old. In the past, salmon poaching in the Lake Kuril region was rife, but now that there is strict protection of this salmon stronghold, the prospects for the new generation of these Kamchatka bears are looking good.

Canon EOS-1DX + 500mm f4 lens; 1/1250 sec at f6.3; ISO 800; Photoseiki tripod.

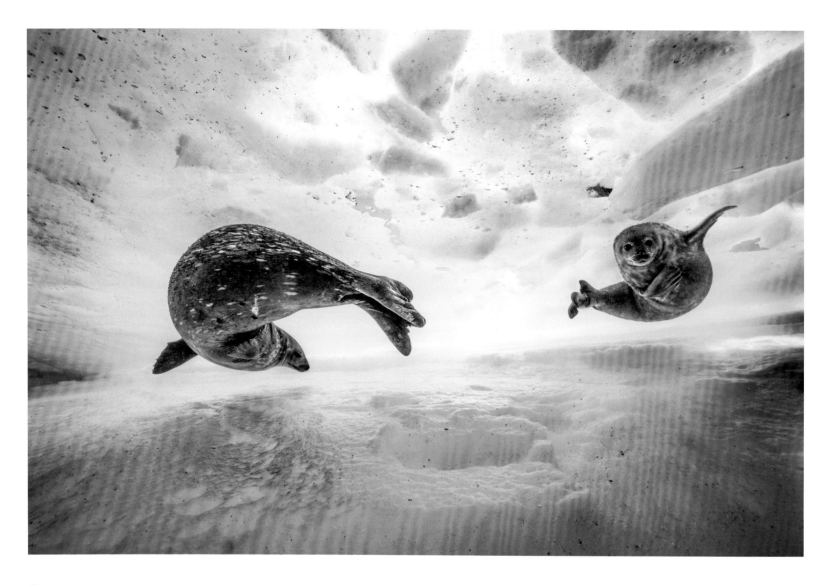

Swim gym

Laurent Ballesta

FRANCE

'We were still a few metres from the surface, when I heard the strange noises,' says Laurent. Suspecting Weddell seals – known for their repertoire of at least 34 different underwater call types – he approached slowly. It was early spring in east Antarctica, and a mother was introducing her pup to the icy water. The world's most southerly breeding mammal, a Weddell seal gives birth on the ice and takes her pup swimming after a week or two. The pair, unbothered by Laurent's presence, slid effortlessly between the sheets of the frozen labyrinth. Adults are accomplished divers, reaching depths of more than 600 metres (1,970 feet) and submerging for up to 82 minutes. 'They looked so at ease, where I felt so inappropriate,' says Laurent. Relying on light through the ice above, he captured the curious gaze of the pup, the arc of its body mirroring that of its watchful mother.

Nikon D4S + 17–35mm f2.8 lens; 1/640 sec at f11; ISO 200; Seacam housing.

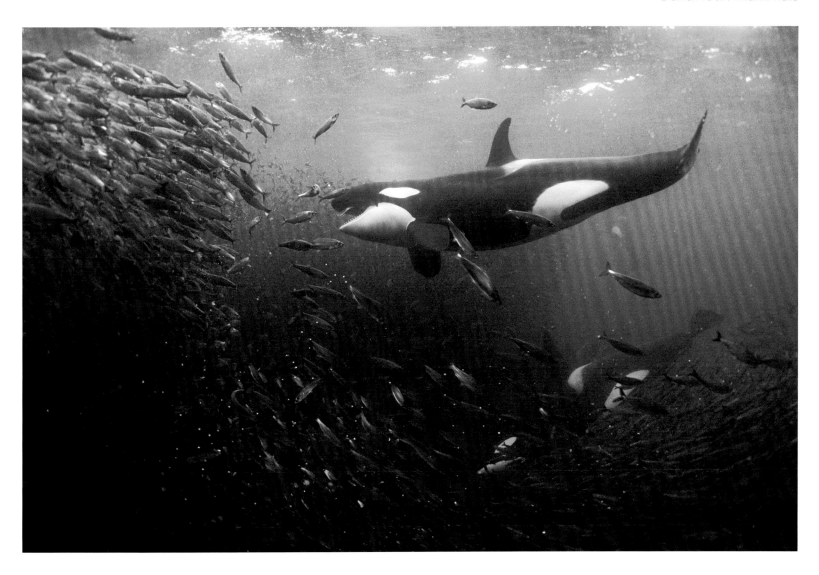

Killer tactics

George Karbus

CZECH REPUBLIC/IRELAND

In the dark Arctic waters of northern Norway killer whales feed on a giant shoal of herring they've herded up against the surface into a tightly packed, swirling ball. The whales move fast, and to keep up with the action, George had to be fit. As a free-diver, he was able to react quickly to changing events and angles, holding his breath for up to two minutes, diving down with the whales as many as 300 times a day and observing some special behaviour, including mothers teaching their calves to hunt. On this November day, he was watching a pod of about 20 killer whales stunning fish with their tails and swallowing them one by one, when suddenly the whales left the baitball. Regrouping – as if having a tactical meeting – they attacked the herring a minute later with a new strategy, holding their mouths open and flying through the baitball at high speed. 'It was the most powerful behaviour I have ever witnessed – an intense, life-changing experience.'

Nikon D5 + 16mm f2.8 lens; 1/250 sec at f4.5; ISO 5000; Subal housing.

Lions' long shot

Michael Cohen

USA

As the downpour that had drenched the dry riverbed in South Africa's Kgalagadi Transfrontier Park began to clear, Michael, sitting in his vehicle, noticed unusual activity far in the distance. A full-grown male giraffe was galloping towards him, with two lions hot on its hooves. Though a few prides have developed strategies to bring down these huge animals, lions tend not to attack adult giraffes, because kicks from those powerful long legs could prove fatal. As the chase drew nearer, Michael saw that this giraffe had misshapen hooves – a factor that may have affected its speed or at least attracted the lions' attention. One lion appeared to tire and pull back, but the older, dark-maned lion sprinted in front of the giraffe and cut off its escape. Then it tried to take the giraffe. But the giraffe threw him off easily, delivering two powerful kicks. A long stand-off followed. The lion and the giraffe stared at each other, the giraffe slowly approaching the lion, alternately lifting first one front leg and then the other in threat. But the lion might have just been buying time, because, abruptly, things changed. The second lion, having caught his breath, suddenly rejoined the hunt, leaping up at the giraffe from behind – as in the picture – grabbing its left rear leg. Caught off balance by the attack from the rear, the giraffe buckled to the ground, and it was all over in minutes.

Canon EOS-1DX + 100–400mm f4.5–5.6 lens; 1/1600 sec at f7.1; ISO 3200.

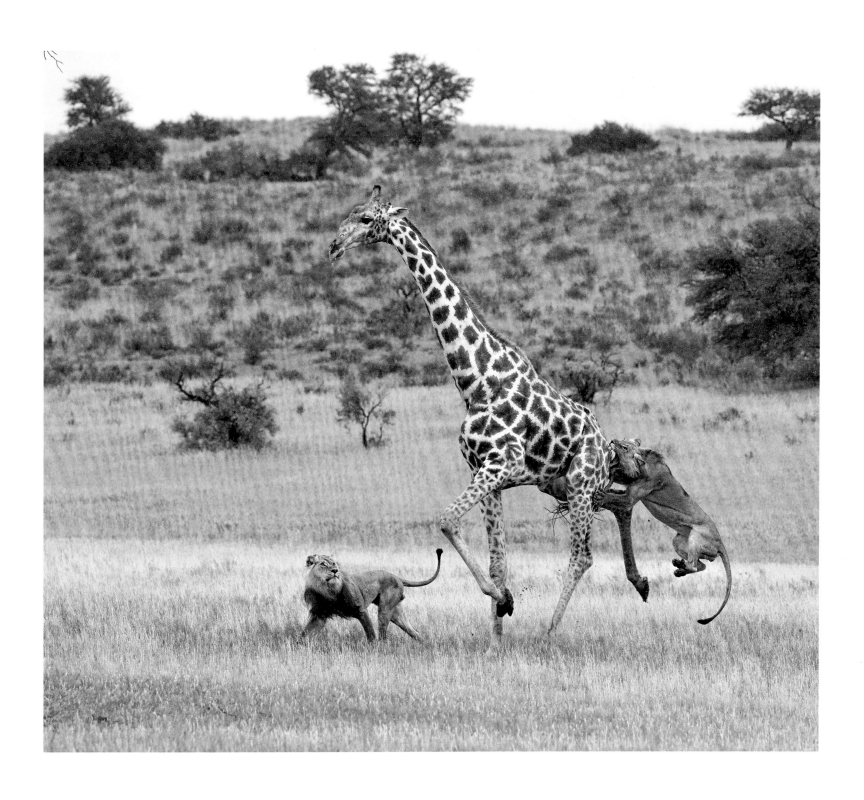

Black and White

Polar pas de deux
Eilo Elvinger
LUXEMBOURG

From her ship, anchored in the icy waters off Svalbard, in Arctic Norway, Eilo spotted a polar bear and her two-year-old cub in the distance, slowly drawing closer. Polar bears are known as hunters, mainly of seals – they can smell prey from nearly a kilometre (more than half a mile) away – but they are also opportunists. Nearing the ship, they were diverted to a patch of snow soaked in leakage from the vessel's kitchen and began to lick it. 'I was ashamed of our contribution to the immaculate landscape', says Eilo, 'and of how this influenced the bears' behaviour.' Mirroring each other, with back legs pressed together (cub on the right), they tasted the stained snow in synchrony. Such broad paws make fine swimming paddles and help the bears to tread on thin ice, and their impressive non-retractable claws – more than 5 centimetres (2 inches) long – act like ice picks for a better grip. Mindful of the species' shrinking habitat – climate change is reducing the Arctic sea ice on which the bears depend – Eilo framed her shot tightly, choosing black and white to 'reflect the pollution as a shadow cast on the pristine environment'.

Canon EOS-1DX + 200–400mm f4 lens at 200mm; 1/640 sec at f9 (+0.7 e/v); ISO 6400.

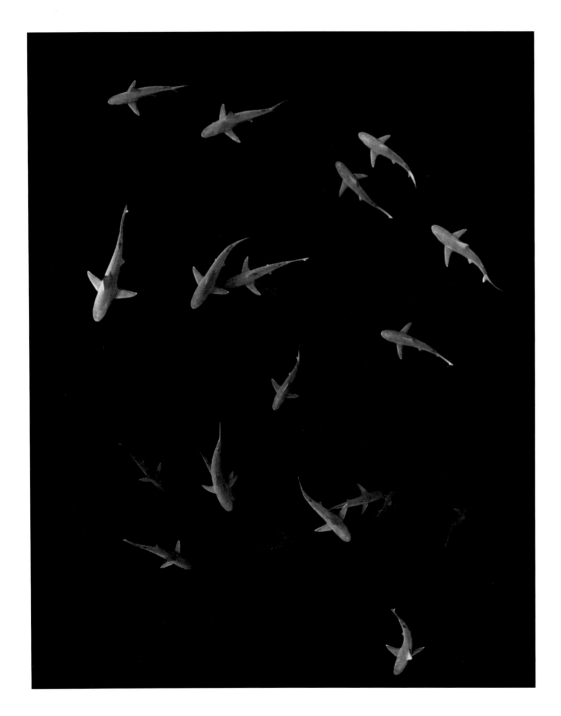

A whorl of sharks
Santosh Shanmuga
USA

The sandbar sharks glided effortlessly below, slipping in and out of the dark like apparitions. These were males, gathering off the Hawaiian island of O'ahu, to be joined by females later in the season (the sexes swim in separate schools, only interacting during mating). They were sizing each other up, the dominant ones securing spots nearer the surface – catching the light – bumping other, smaller individuals back down. Every now and then, one would rise up to check out Santosh, exchange a look – that felt like a mutual respect – then sink to rejoin the school. Sandbar sharks are large and stocky, growing slowly to reach up to 2.4 metres (8 feet) long. Though not fished in Hawaiian waters, their late sexual maturity (at up to 15 years old in some areas) and low reproductive output (females give birth to 1–14 pups every other year at most) make them vulnerable to overfishing across most of their range. They are widespread in coastal areas, but their huge dorsal fins are rarely seen protruding from the water – they prefer to cruise near the bottom, looking for prey, mostly small fish. Shooting directly down with a wide-angle lens, Santosh concentrated on their forms and patterns created by their graceful movements, highlighted in black and white.

Nikon D4 + Sigma 15mm f2.8 lens; 1/200 sec at f7.1; ISO 1000; Nauticam housing + Zen dome port.

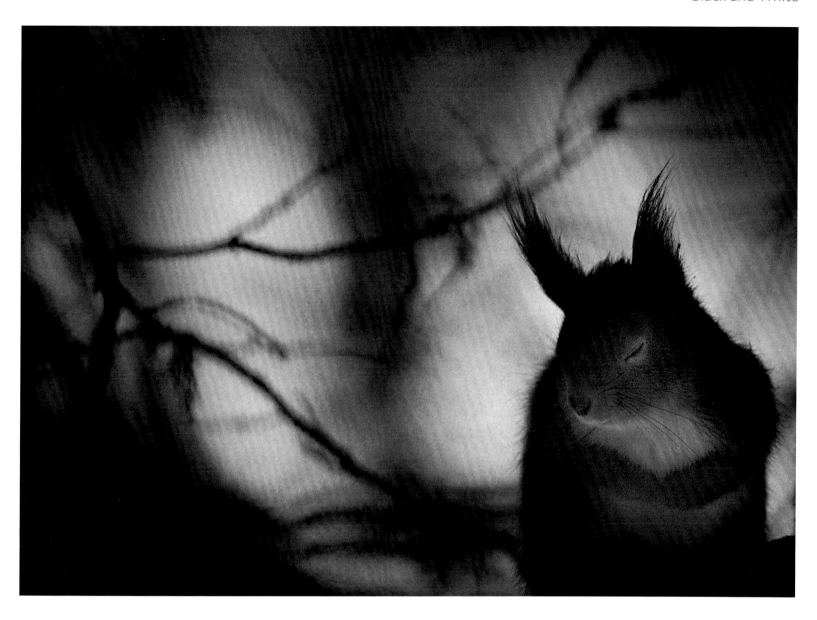

Winter pause
Mats Andersson
SWEDEN

The red squirrel closed its eyes for just a moment, paws together, fur fluffed, then resumed its search for food. Winter is a tough time for northern animals. Some hibernate to escape its rigours, but not red squirrels. Mats walks every day in the forest near his home in southern Sweden, often stopping to watch the squirrels foraging in the spruce trees. Though their mainly vegetarian diet is varied, their winter survival is linked to a good crop of spruce cones, and they favour woodland with conifers. They also store food to help see them through lean times. On this cold, February morning, the squirrel's demeanour encapsulated the spirit of winter, captured by Mats using the soft-light grain of black and white.

Nikon D3 + 300mm f2.8 lens; 1/320 sec at f2.8; ISO 800.

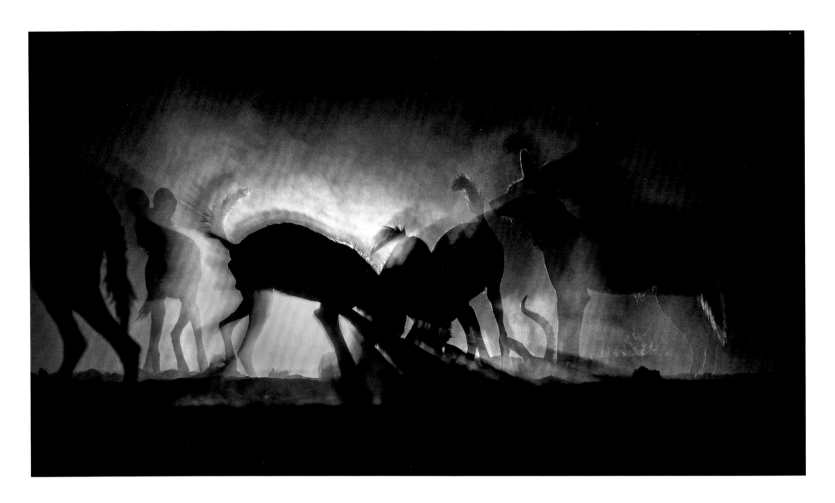

Dog's dinner
Greg du Toit
SOUTH AFRICA

For African wild dogs, it's all about the pack. When Greg returned at dusk to his camp in a remote area of Zimbabwe's Mana Pools National Park, he found nearby a single dog standing over a male impala it had just brought down. Within minutes, the rest of the pack of about 12 dogs caught up with it, and they all started to devour the meal. Rather than stalk their prey, wild dogs run it down, showing incredible stamina over long distances. These endangered carnivores are rarely seen, hunting in packs at dawn and dusk in expansive home ranges of up to 5,000 square kilometres (1,930 square miles). Fewer than 6,600 adults remain in a declining population threatened by habitat fragmentation, disease and conflict with humans. Greg lay in the sand, trying to compose a wide shot amid the frenzy. 'I was determined to reveal the pack as a collective unit,' he explains. The dogs' shadows were cast on the wall of white dust kicked up from the dry riverbed, fortuitously backlit by a neighbouring camper's torch. The moment came as one dog exited left, another stood still (right), one flaunted its impressive ears, while the horns of the victim rose up through the dust.

Nikon D4S + 80–400mm f4.5–5.6 lens at 290mm; 1/320 sec at f8 (+1 e/v); ISO 3200.

Snow spat
Erlend Haarberg
NORWAY

As spring comes to Norway's upland birch forests, tension grows between mountain hares. Under cover of darkness, they become more active, fighting over females and food. Erlend spent many springs and countless freezing nights in a hide, waiting for their company and watching their antics. Prey for predators, including humans, the hares were always cautious, but they did get used to the camera clicks. He put out food to attract them closer and illuminated the area with lamps, which didn't seem to bother them (they moved in and out of the light with confidence). Months of work came together one night in heavy snow, when two individuals started squabbling over food. Snowflakes flying, Erlend froze the action, capturing the rivals' postures perfectly balanced and backlit. Converting his image to black and white accented the drama of this unique moment.

Nikon D800E + 300mm f2.8 lens; 1/1600 sec at f2.8; ISO 3200; Gitzo tripod + UniqBall head; two 1000W lamps.

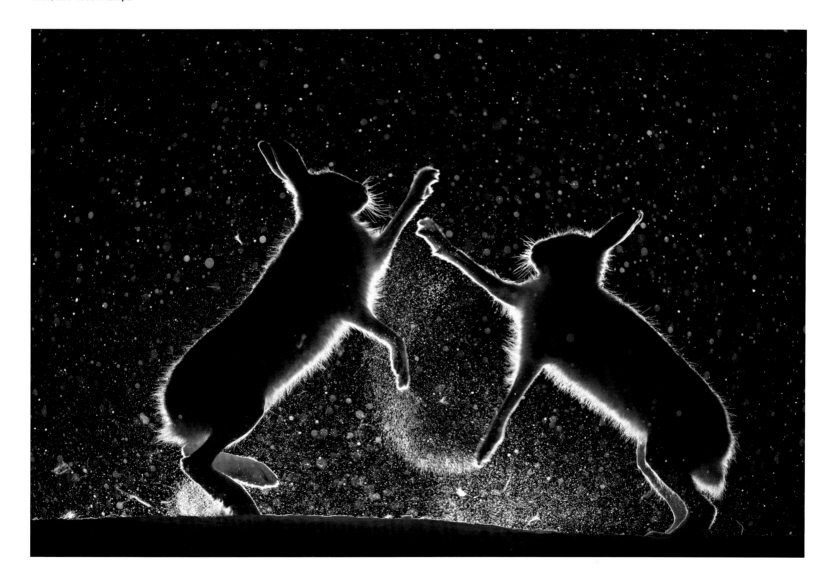

Urban Wildlife

Cat attack
Stefano Unterthiner

ITALY

Stefano was alerted by high-pitched cries ringing out over the roof – the alarm calls of lesser kestrels – signalling that a cat was on the rooftops, where at least 20 pairs of kestrels were nesting. Sure enough, the agitated birds were flying over a cat roaming too close to their nests. Stefano was living in the historic town of Matera in southern Italy to document the lives of the lesser kestrels. He set his alarm for 5.30 every morning, when the birds were most active, the streets quiet and the light soft. The ancient town, carved out of limestone cliffs, is home to Europe's largest breeding colony of lesser kestrels – more than 1,000 pairs – returning each year from overwintering in sub-Saharan Africa to nest on the town's rooftops, on window ledges and in crevices in buildings and walls. It's rare to see raptors so close together and so entwined with human life. They are welcomed by Matera's human residents, and conservationists, with EU funding, have installed nestboxes on the roofs. On this morning, one particular female kestrel was relentlessly harassing the cat, swooping low over and over again, frantic to drive it away from her chicks inside the nearby nestbox. Leaning over his terrace, Stefano waited for the moment when the cat swiped at the kestrel, took his shot and then joined in the mobbing to make sure the cat left the scene.

Nikon D500 + 200–400mm f4 lens; 1/2000 sec at f4; ISO 1000; Gitzo tripod.

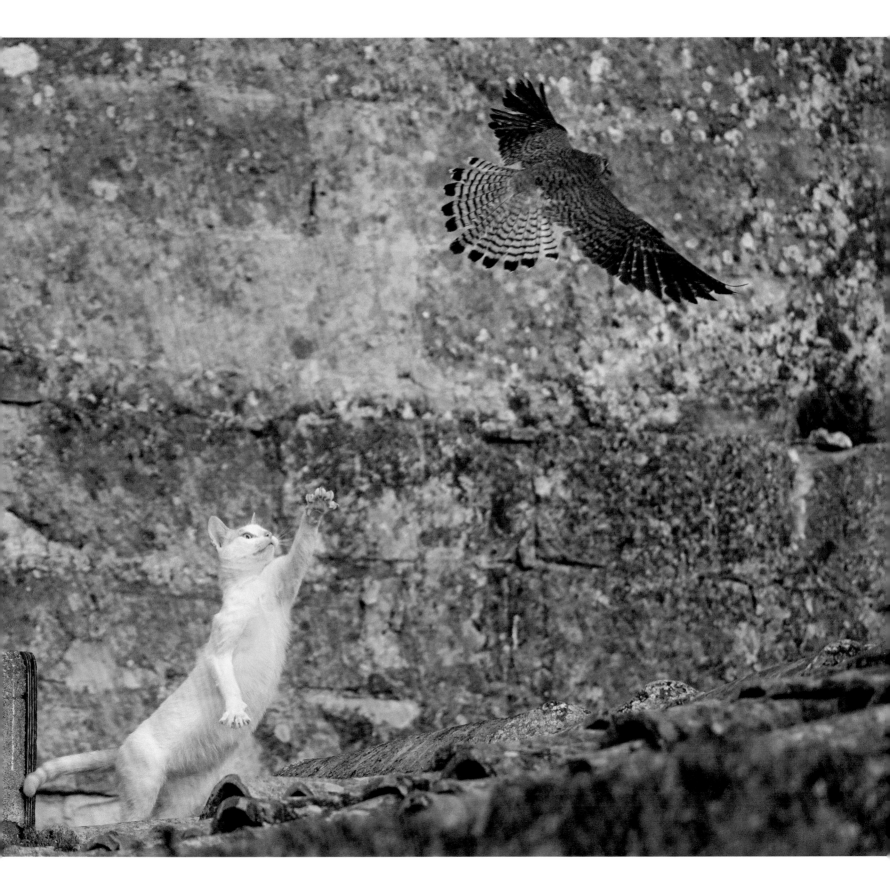

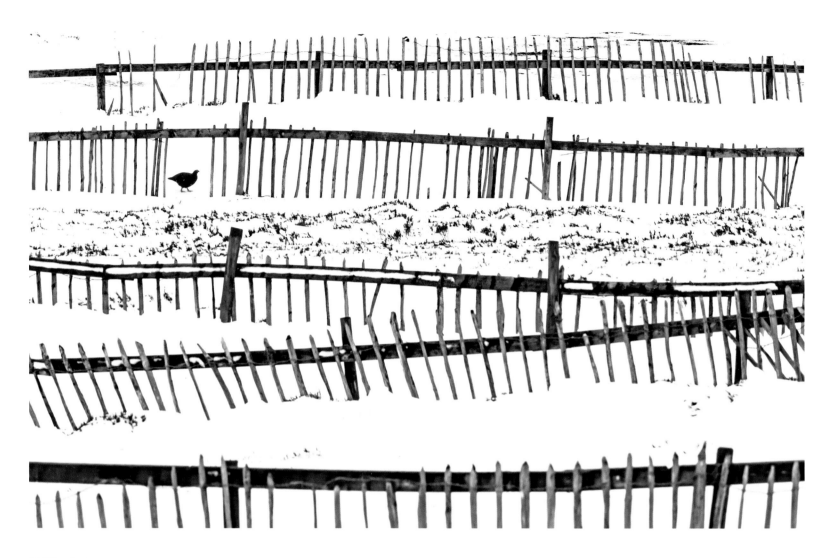

Off piste
Hugo Wassermann
ITALY

With most of the slopes closed because of lack of snow and ski lifts out of operation, the ski resort in Scotland's Cairngorm National Park attracted a different kind of visitor – red grouse. The birds ambled at leisure through the patchy snow, moving only slightly to make way for the occasional member of staff and maintenance vehicle. The development of ski resorts has inevitably had an impact on wildlife, with red grouse flying into ski wires, losing eggs to the increased crow populations, and losing feeding areas to vegetation damage and soil erosion. But after watching for a while, Hugo realized that the birds seemed to favour the areas around the fences that separated the many narrow ski slopes from the ski lifts. On one side of the fences there tended to be less snow on the ground, which perhaps made it easier for the birds to reach vegetation. Hugo was taken by the pattern of the fences, set up his tripod and composed his shot, waiting until a grouse wandered into the right gap in the grid.

Canon 5D Mark III + 500mm f4 lens; 1.4x extender; 1/160 sec at f29; ISO 1000; Gitzo tripod.

Bay of egrets
Roberto González García

SPAIN

Every evening, vast numbers of cattle egrets roost in the reedbeds of the port area of the Bay of Santander in northern Spain. And every morning, they take to the air – a spectacle that humans working in the shipyard barely notice. Originally from Africa, cattle egrets have spread across the world, reaching northern Spain in the late 1980s. Their adaptable diets, foraging habits and dispersal tendencies have enabled them to colonize both agricultural and urban environments, and today about 4,000 are found in the bay area. To create his image, Roberto had to wait for three events to combine: the docking of a passenger ferry; a high tide that forces the roosting egrets to take flight; and a date when human activity would begin before sunrise so that the lights would be on. The result is a dream-like dawn scene of the awakening shipyard and the departure of the egrets to their feeding grounds – humans and birds going about their own business.

Canon EOS 7D + 24–105mm f4 lens; 0.3 sec at f4; ISO 400; Manfrotto tripod; remote control.

The tyre nightjar
Jaime Culebras

SPAIN

The camouflage plumage of an Anthony's nightjar may have evolved to mimic bark and leaf-litter, but as Jaime discovered, it works equally well against the mud and treads of a car tyre. Jaime spotted the bird at the end of a night looking for frogs and snakes on a farm in Ecuador's Jardin de los Sueños Reserve. Nightjars are among his favourite birds, and Anthony's is one of the least known. Not wanting to disturb the sleeper by setting up his camera, he passed on the photo opportunity. But when he saw it again the next day, he realized he might have another chance. 'I am always surprised how much wildlife is living under cover right alongside us,' he says. The following night, while the nightjar was hunting insects around the farm, he set up beside the car and waited – and waited. Just before sunrise the bird returned and settled on its favourite tyre, rewarding Jaime for his patience.

Canon 6D + 17–40mm f4 lens at 17mm; 1/60 sec at f10; ISO 640; two Yongnuo Speedlite flashes; softbox; Manfrotto tripod; remote wireless trigger.

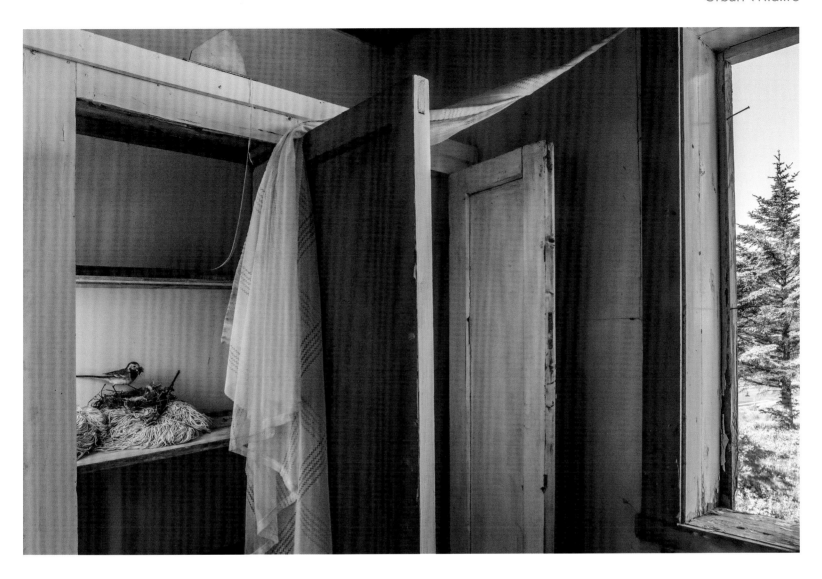

Shelf life
Pål Hermansen

NORWAY

While viewing the photographic potential of an abandoned house on Gimsøya – one of the Norwegian Lofoten Islands – Pål noticed a bird flying in and out of a broken window. Investigating, he discovered that a pair of white wagtails had picked the perfect nesting spot on top of an old mop head on a cupboard shelf. Snug inside a cup of twigs, roots and moss was a brood of half-grown chicks that both parents were feeding regularly with beakfuls of insects. So as not to disturb the birds – the adults were shy and kept out of the house when he was there – he quickly set up a remote camera with a monitor that he could control from his car, allowing him to spend a few days with the family. Using a tilt-shift lens to show the whole wide scene while minimizing distortion, he pulled together the birds' story – the house-sitting, their mop nest and the view of nature outside.

Canon EOS 5D Mark III + 24mm f3.5 tilt-shift lens; 1/6 sec at f13; ISO 250; remote release; Canon Speedlite flash (low power) + softbox; Benro tripod.

Earth's Environments

The ice monster
Laurent Ballesta

FRANCE

Laurent and his expedition team had been silenced by the magnitude of the ice blocks – mountainous pieces of the ice shelf – awed in the knowledge that only 10 per cent of their volume is ever visible above the surface. The dive team were working out of the French Dumont d'Urville scientific base in east Antarctica, recording with film and photography the impact of global warming. Ice shelves in some parts of the East Antarctic Ice Sheet are melting faster than scientists had previously assumed, threatening a movement of land ice into the sea and raising sea levels dramatically. When Laurent spotted this relatively small iceberg, he saw the chance to realize a long-held ambition – to show for the first time the underwater part. The berg was stuck in the ice field – hovering like a frozen planet – unable to flip over and so safe to explore. But it took three days, in virtually freezing water, to check out the location, install a grid of lines from the seabed to buoys (so that Laurent could maintain a definite distance from it) and then take the series of pictures – a substantial number, with a very wide-angle lens – to capture the entire scene. 'None of us could see the whole thing under water. Close-to, it was overflowing from our view. From a distance, it disappeared into the fog.' So, back at the station, it was a tense wait at the computer, while the result of 147 stitched images came together on screen. The front of the vast foot of the frozen monster, polished by the current probably over years, shone turquoise and blue in the light penetrating the ice ceiling, dwarfing Laurent's companions as they lit its sides.

Nikon D4S + 13mm f2.8 lens; 1/30 to 1/60 sec at f6.3 –147 stitched images; ISO 3200; Seacam housing; flashlights.

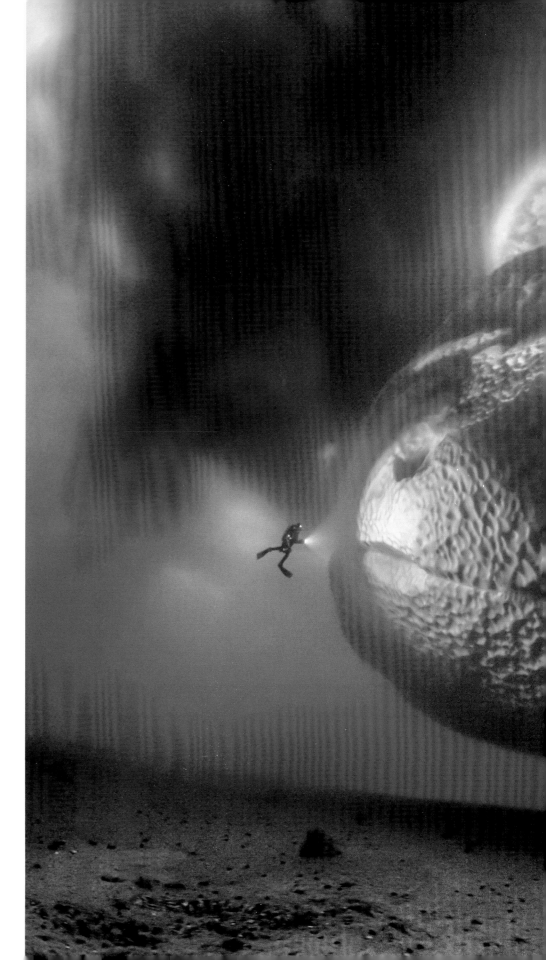

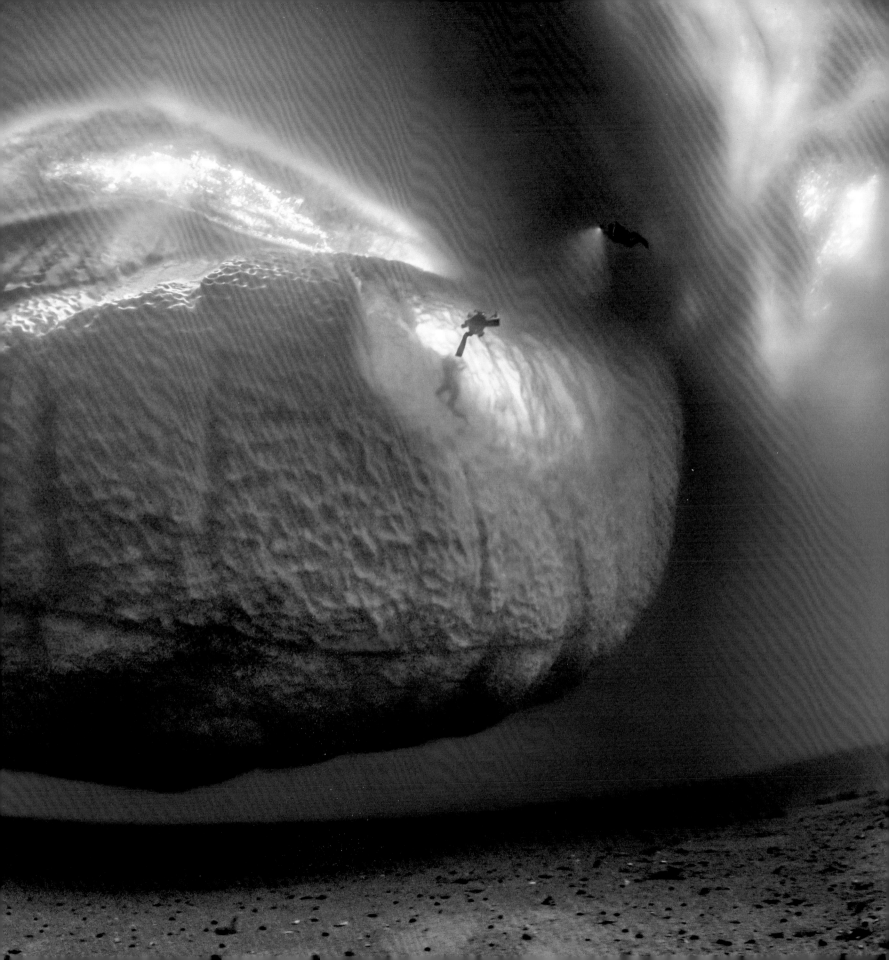

Fire ice

Chris Bray

AUSTRALIA

This is the transition zone, where the Mýrdalsjökull ice cap in southern Iceland starts to bend and flow into the valley below. As it creeps outwards, its edge fractures under the weight and pressure, releasing an eerie blue glow from each crevasse. The frozen blocks begin a slow-motion cascade towards the melting face of the glacier (now steadily retreating as temperatures rise). Only the dark strata of ash lacing the white architecture hint at the simmering fire beneath, for the vast ice cap conceals the top of Katla, a large, restless volcano. Fine ash (tephra) has been deposited by previous eruptions every 40–60 years – the last, ominously, in 1918. As his helicopter lifted over the edge, Chris framed his shot through the open door, battling against the raw wind and turbulence to capture the scale-defying forms of fragmented ice.

Canon EOS 5DS R + 24–105mm f4 lens at 105mm; 1/1600 sec at f5; ISO 250.

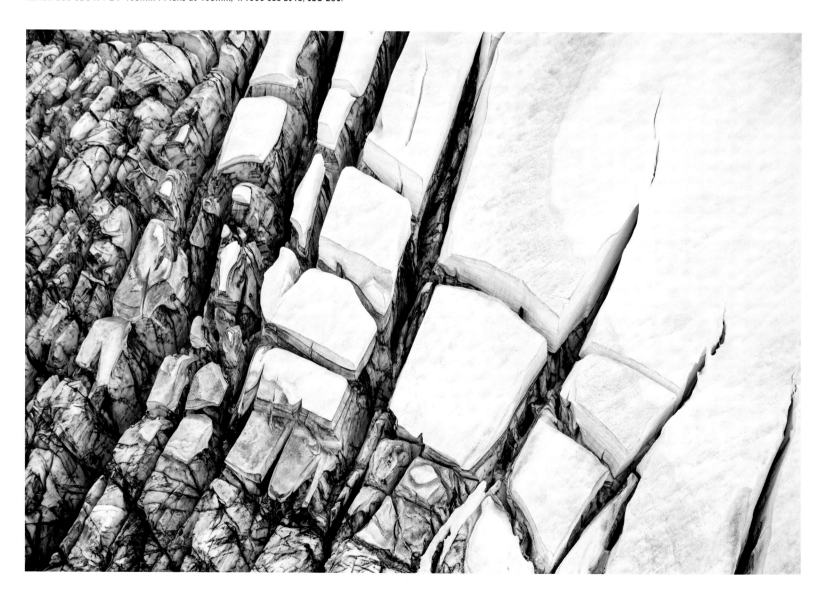

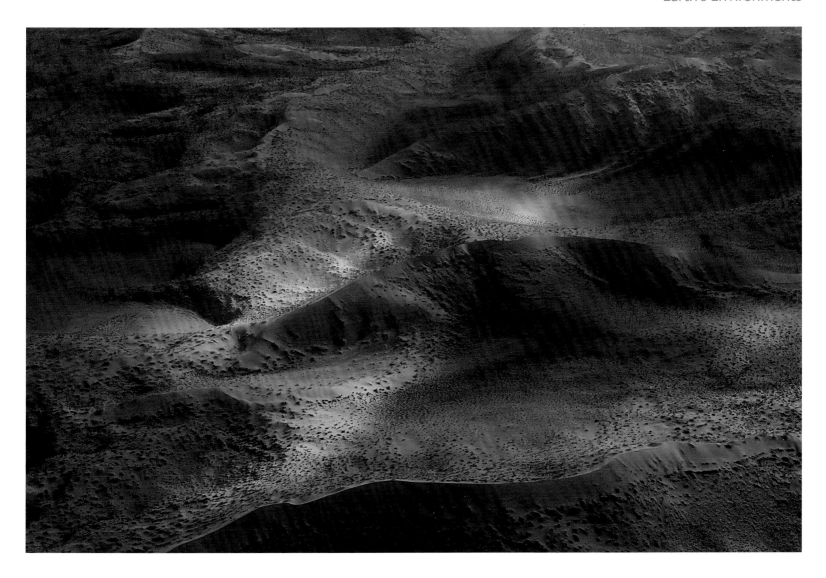

Desert canvas
Angiolo Manetti
ITALY

Angiolo had dreamed of flying over the Namib Desert at sunset to see the light playing across this venerable landscape, and he wasn't disappointed. Viewed from a small plane, the sand of Namibia's Namib-Naukluft National Park stretched far into the distance. The last rays of the sun caught the tops of the dunes and glimmered in the valleys, creating a bewitching pattern, 'like the painting of a great artist'. The Namib is one of the world's biggest and oldest deserts, and is largely devoid of surface water, receiving sparse and unpredictable rainfall. Yet its contours are in places roughened with vegetation (some 3,500 species of plants grow here, many found nowhere else). Their life-blood is fog, swept inland from the coast, and groundwater. Shooting through glass, and undeterred by turbulence, Angiolo captured the last of the light as it painted the endless dunes with gold.

Nikon D7000 + 18–200mm f3.5–5.6 lens at 35mm; 1/1600 sec at f9; ISO 800.

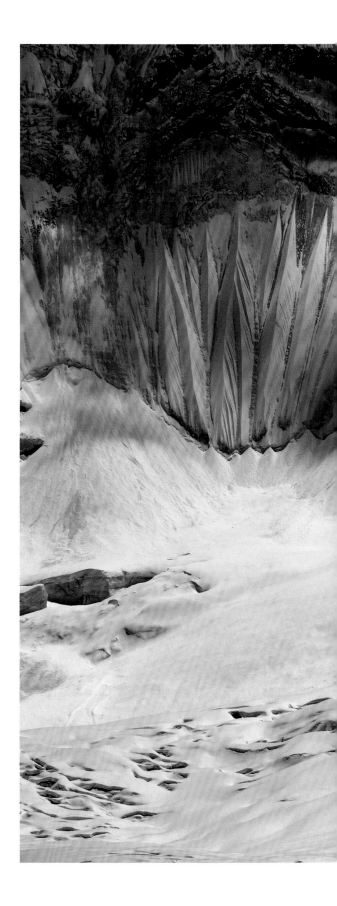

The unstoppable force
Paddy Scott

UK

Paddy was about halfway across the valley when the avalanche struck. He had spent weeks in the Himalayas, Pakistan, listening to the thunder of snow as it slid from K6. At first, he had been startled by even the most distant noise, but gradually he had become accustomed to the roars and transfixed by the endless drama of the mountain's face. He was there to document an expedition to climb to the peak of the as-yet unassailed Link Sar, and that morning he was following the climbers, who were hiking from base camp to assess conditions on the peak. Progress was slow and difficult – the valley was littered with giant boulders deposited by the glacier that had carved it, and blanketed in snow and ice – but suddenly he was stopped in his tracks. Dwarfed by the immense backdrop, the avalanche seemed to tumble in slow motion, billowing gracefully as it puffed up clouds of snow and ice. In fact, it took little more than a minute to crash down at great speed with enormous destructive power. Quickly framing his shot with a jagged ridge to give depth and scale, Paddy captured the unstoppable force that at once brought both fear and calm.

Canon EOS 5D Mark III + 70–200mm f2.8 lens at 173mm; 1/640 sec at f11; ISO 100.

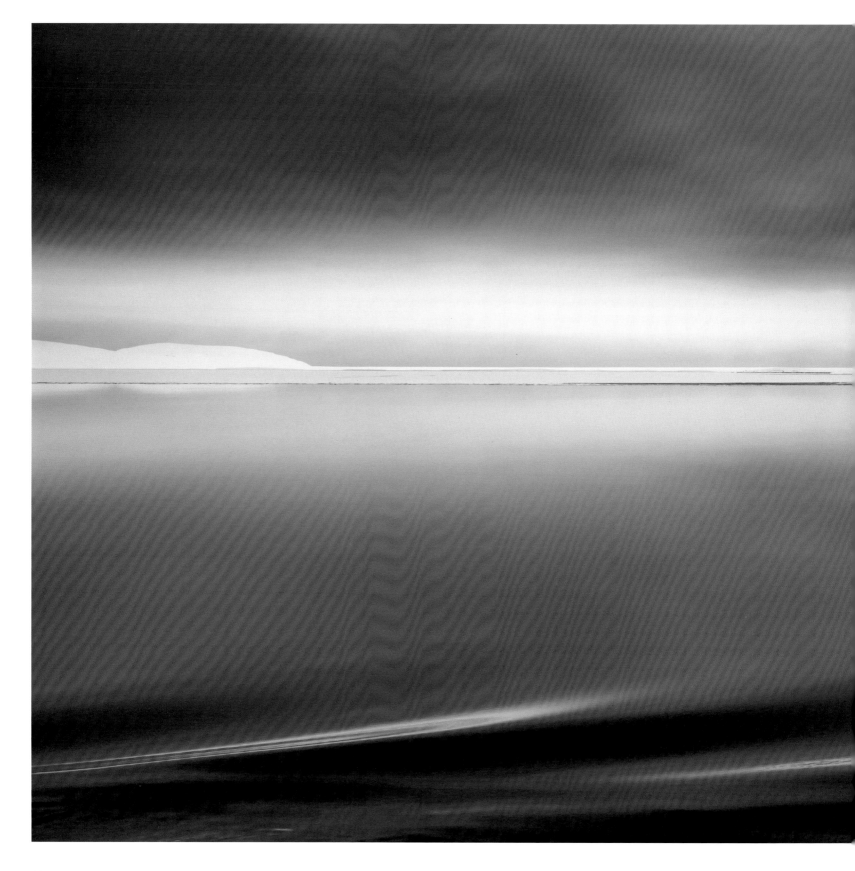

Arctic blues
Reiner Leifried

GERMANY

The best vantage point was on the lowest possible level of the ship. 'I was looking for calmness with an endless view,' explains Reiner. His first trip to the Arctic in summer had sparked a fascination with this wilderness, which drew him back in early spring. On a cloudy morning, his ship was cruising – very slowly – through Liefdefjorden, in the northwestern corner of Svalbard. In this realm of polar bears, his focus was on the atmosphere – enhanced by the blue light – and the landscape, entirely blanketed in snow and ice. 'I wanted to capture them in the most reduced way possible.' The water in the fjord was deep, its surface on the cusp of turning from liquid into ice. Like a mirror in the stillness, it gifted reflections of the land's white contours and the moody sky, while in the distance, light bounced off the ice to brighten the clouds. Reiner framed his shot with a smooth wave from the ship's gentle motion rippling the icy water like folds of satin. 'For me, this picture represents the "quiet alertness" state of meditation,' he says. 'Calm, slow-paced, but still strong and highly present.'

Nikon D810 + 14–24mm f2.8 lens at 24mm; 1/500 sec at f8 (–1 e/v); ISO 1000.

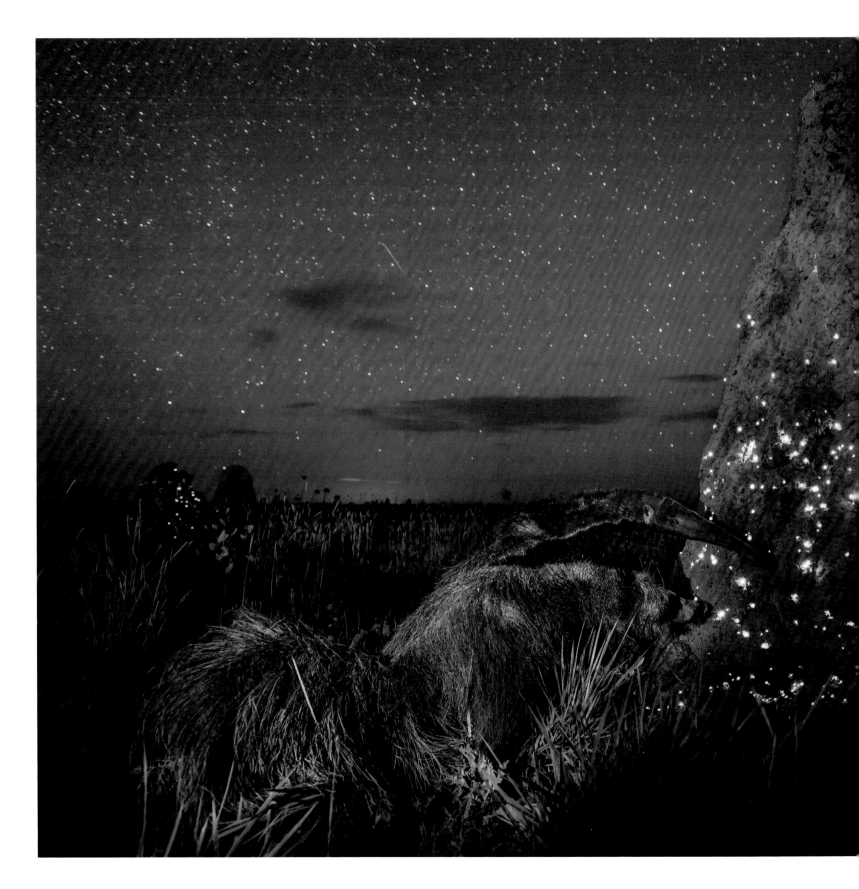

Animals
in Their Environment

The night raider
Marcio Cabral
BRAZIL

It was the start of the rainy season, but though the night was humid, there were no clouds, and under the starry sky, the termite mounds now twinkled with intense green lights. For three seasons, Marcio had camped out in Brazil's cerrado region, on the vast treeless savannah of Emas National Park, waiting for the right conditions to capture the light display. It happens when winged termites take to the sky to mate. Click beetle larvae living in the outer layers of the termite mounds poke out and flash their bioluminescent 'headlights' to lure in prey – the flying termites. After days of rain, Marcio was finally able to capture the phenomenon, but he also got a surprise bonus. Out of the darkness ambled a giant anteater, oblivious of Marcio in his hide, and began to attack the tall, concrete-mud mound with its powerful claws, after the termites living deep inside. Protected from bites by its long hair and rubbery skin, the anteater extracted the termites with its exceptionally long, sticky tongue. It has limited vision but a keen sense of smell to help locate insects. Luckily, the wind was in Marcio's favour, and the anteater stayed long enough for him to make his picture, using a wide-angle lens to include the landscape, a low flash and a long exposure to capture both the stars and the light show.

Canon EOS 5DS R + Nikon 14–24mm f3.5 lens + Fotodiox adapter + ND filter; 30 sec at f3.5; ISO 5000; two Metz 32 flashes + diffuser; Manfrotto tripod.

A magnificence of monarchs
Jaime Rojo
SPAIN

As the sun set over the mountains of central Mexico, the forest of sacred firs became enchanted with golden light. Branches clothed in millions of monarch butterflies drooped as the insects crowded together for warmth. Though Jaime had often witnessed this spectacular winter gathering, it was the first time he had a permit to stay until sunset in the Monarch Butterfly Biosphere Reserve. Every autumn, the monarchs migrate from breeding grounds in North America up to 4,800 kilometres (3,000 miles) to overwinter in Mexico, where they form some of the largest species aggregations known – half a billion in the 1990s, though with a precipitous decline more recently, bringing numbers down to less than 50 million. The primary threats are illegal logging at the winter sites, increased pesticide use, habitat loss and climate change. The year 2013 saw the lowest estimate ever recorded, just 33 million. But here the butterflies were as thick as ever. To photograph them at last light meant finding the right spot at the right moment, but leaving enough time to get down the mountain before darkness fell. Chasing the light, Jaime found himself running back uphill with his equipment to this glade, where 'the trembling, intricate tapestry' of butterflies filled the frame, catching it backlit by the setting sun. Just one individual opened its wings, adding a magic flash of colour.

Nikon D4 + 70–300mm f4.5–5.6 lens at 155mm; 1/8 sec at f11; ISO 1250; Gitzo tripod.

The mud crowd

Mark Cale

UK

Though the rains were due, the rivers in Tanzania's Katavi National Park were now little more than a series of mud pools. In one pool, a crowd of hippos jostled for position, trying to keeping cool, their hairless skin protected in part against sunburn and dehydration by the secretion of an oily mask. Mark appreciated the patterns drawn by the shifting bodies and kept a lookout for clashes between rivals. What he hadn't expected was the arrival of a Nile crocodile in search of a basking spot. Hippos have huge canines and have been known to kill crocodiles, but both animals have respect for each other. The hippos nearest to the crocodile therefore chose to retreat, barging into their neighbours and causing a domino-like ripple of panic, each hippo shoving the next. Keeping close to his vehicle, with an eye on the agitated crowd (hippos are surprisingly fast on land – and kill more people in Africa than any other mammal), Mark framed the commotion set off by the bold reptile.

Nikon D810 + 70–200mm f2.8 lens at 86mm; 1/500 sec at f8; ISO 640.

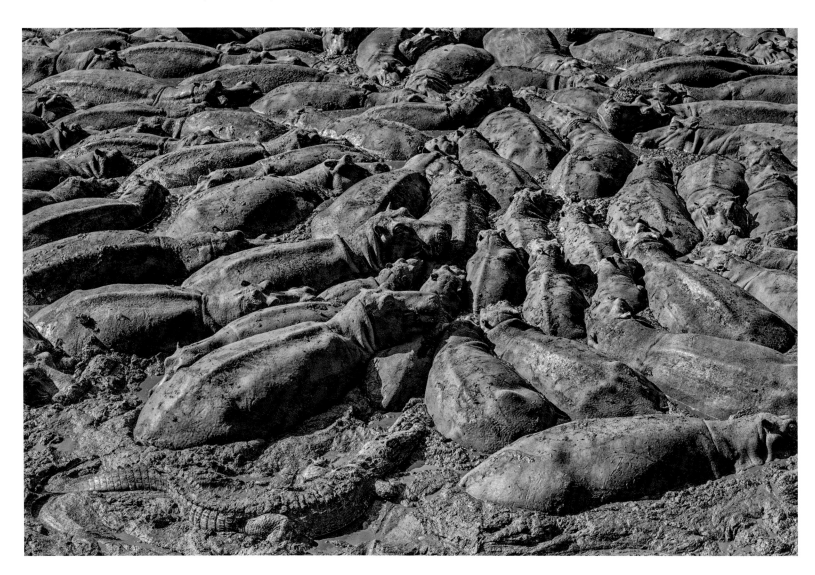

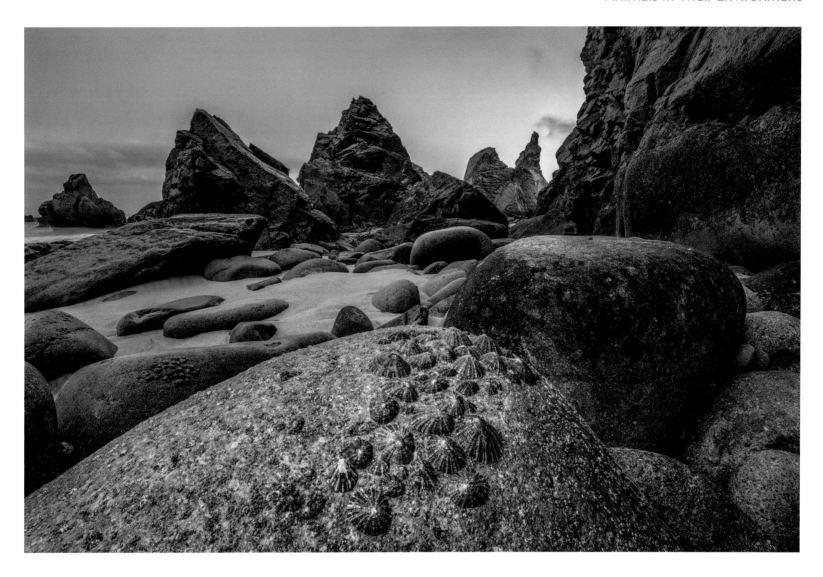

Limpet exposure

Theo Bosboom

THE NETHERLANDS

It was a long, steep scramble in the dark to catch the blue light before sunrise on Portugal's Sintra coast – a dramatic backdrop to celebrate a familiar subject, which has legendary sticking power. A muscular foot clamps the limpet's shell to a rock, grinding it in for a perfect fit that will stop it drying out. When submerged by the tide, the limpet moves around to scrape algae off the rock with a tongue bristling with tiny teeth. These are made of an iron-based mineral–protein composite – the strongest-known natural material. As the tide retreats, the limpet follows its own mucous trail to return to its tailor-made base. To get both limpets and distant rocks in focus and correctly exposed, Theo merged 21 images using focus stacking and HDR (high-dynamic range) techniques. A masked flashlight gave a radiant touch to the limpets, while the dawn picked out the hues of the jagged rocks.

Canon EOS 5DS R + Laowa Venus 15mm lens; 1 sec (average over 21 images) at f16; ISO 1250; Gitzo tripod + Really Right Stuff ballhead + Novoflex focusing rail; flashlight.

Sheer endurance
David Pattyn
BELGIUM

It was early winter, and there had been heavy snow in Italy's Gran Paradiso National Park. Not only did this mean a greater risk of avalanches but also that the lone male Alpine ibex David was searching for would have moved to the steeper parts of the valley, where there were areas where it could feed, swept clear of snow by the wind. The ibex is endemic to Europe, native to the Alps and emblematic of the mountainous Gran Paradiso – Italy's first national park, created in 1922 to protect this species, which had been hunted to the brink of extinction. The park's population grew steadily from a few hundred to nearly 5,000 by the 1990s. But in the past 20 years, this has halved. Climate change may be to blame – an earlier spring means the most nutritious new grass is emerging sooner than the mothers give birth, which may affect the kids' survival rate. It took a week before David finally found the male, lower down, glimpsed through lightly falling snow, and was able to follow him from a distance. As the snow grew heavier, the male sought shelter on a precipitous ledge beneath overhanging rocks, allowing David to frame his shot. With quiet endurance, it stood motionless – stately in its thick winter coat and imposing backward-curved horns – almost invisible against the rocky backdrop.

Canon EOS-1DX + 100–400mm f4.5–5.6 lens at 176mm; 1/320 sec at f6.3; ISO 800.

Realm of the condor
Klaus Tamm

GERMANY

Hiking across the challenging terrain of Torres del Paine National Park, Chile, with several Andean condors soaring high above, Klaus contemplated their existence in this unforgiving landscape. With wingspans of more than 3 metres (10 feet), Andean condors are among the world's largest flying birds, with sharp, hooked beaks and powerful claws for scavenging a living, mostly from the remains of livestock that die in the Andes. They watch the behaviour of animals that might lead them to a meal, and can spot a carcass from several kilometres away. Though they can live to be more than 50 years old, they breed very slowly – females lay a single egg every other year, and both parents are needed to rear a chick, which can't fly until it is six months old and is dependent for two years. Such a low output makes the species very vulnerable to human persecution, which persists largely because of the mistaken belief that condors kill livestock but also includes killing for sport. Suddenly, one of the birds dropped down and began circling in front of the glacier. Relieved to have his camera kit with him (he had almost left the weight behind and hadn't brought a tripod), Klaus quickly steadied his long lens, capturing the magnificent bird silhouetted against the icy peaks, its distinctive white neck ruff just visible.

Canon EOS-1DX + 800mm f5.6 lens at 800mm; 1/400 sec at f25 (–1.7 e/v); ISO 125.

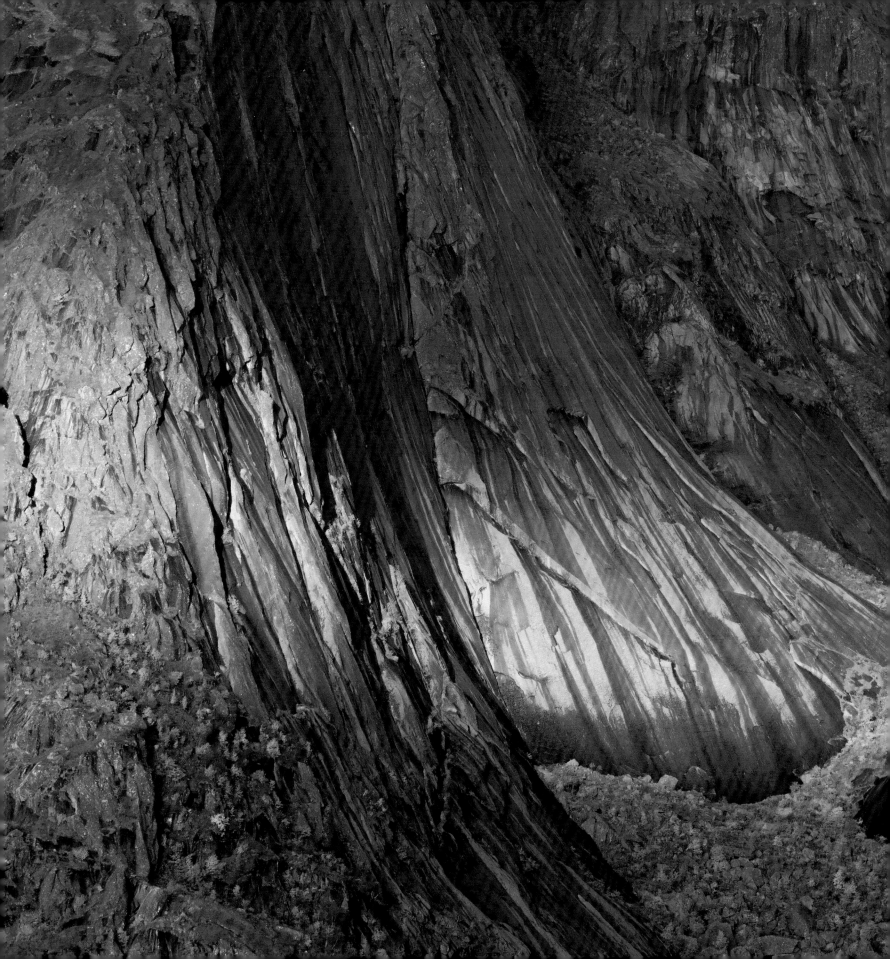

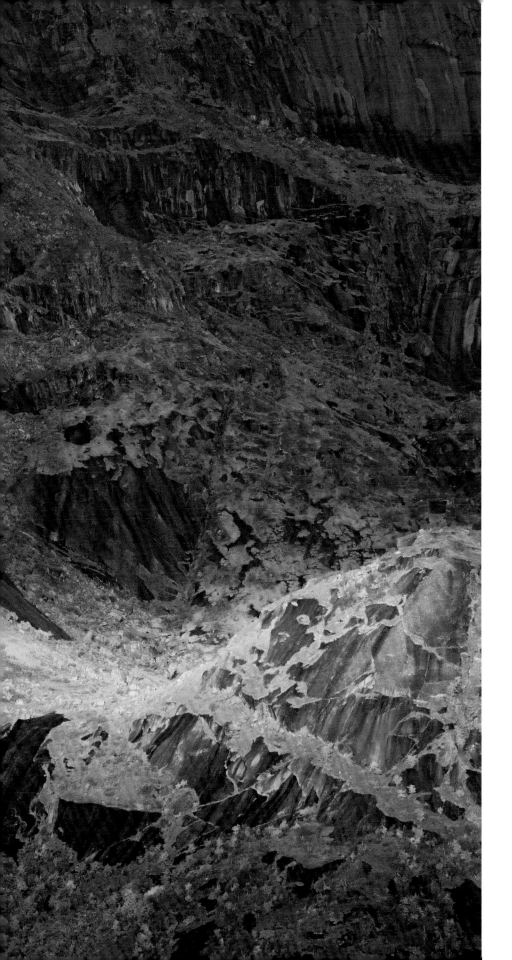

Plants and Fungi

Tapestry of life
Dorin Bofan
ROMANIA

It was a quiet morning with flat light as Dorin stood alone on the shore of the fjord. He was contemplating the immense landscape bounding Hamnøy in the Lofoten Islands, Norway, when here and there, the clouds parted, allowing shafts of sunlight to fall on to the great walls of metamorphic rock, lighting up the swathes of vegetation coating the canyon and its slopes. The mountains here rise steeply from the sea – a sheer drop of 200 metres (660 feet) in some places – yet mountain birches manage to gain a foothold, some clinging to existence in the most precipitous spots. This mountain variety of downy birch is relatively small, and here in its autumn colours, is glowing gold. Dwarf willow species carpet much of the ground below. Drawn to the gentle curve at the base of the rock-face – like the 'moss-covered trunk of a veteran tree in a damp ancient wood' – Dorin composed his picture, waiting until a break in the clouds yielded this brief moment in a timeless landscape, cloaked in a tapestry of Arctic–alpine vegetation.

Canon EOS 650D + 70–200mm f4 lens at 100mm; 1/100 sec at f5.6 (-1 e/v); ISO 200; Manfrotto tripod.

Freshwater Eden
Michel Roggo
SWITZERLAND

It was the dry season, and with clear water and a temperature of 34°C (93°F), Michel was having fun drifting along, exploring the underwater jungle, here a tangle of water hyacinth. He was snorkelling in a small tributary of the Rio Paraguay in Brazil, on his second visit to the vast Pantanal – a patchwork of lagoons, rivers, lakes and marshes. It's the world's largest tropical wetland, stretching from Brazil into Bolivia and Paraguay. Most of it is submerged in the rainy season, an annual cycle of floods that nurtures one of the world's most biodiverse regions. 'I've never seen any place on Earth with such diversity of forms, shapes and colours,' says Michel, who returned to the Pantanal as part of his Freshwater Project, an epic photographic journey to reveal the undervalued beauty of fresh water. 'Though there are piranhas and caimans in this freshwater Eden, it's not really dangerous,' he says, 'but you always have this strange feeling of being observed by hundreds of eyes... I was once bitten on my toes, but it was only a male jacunda fish defending its nest.' When he came across this scene 'like an impressionist painting', he knew he had his picture. 'The longer you look, the more you see, and that is the Pantanal.'

Sony Alpha ILCE-7R + Zeiss FE 16–35mm f4 lens; 1/100 sec at f8; ISO 400; Nauticam housing.

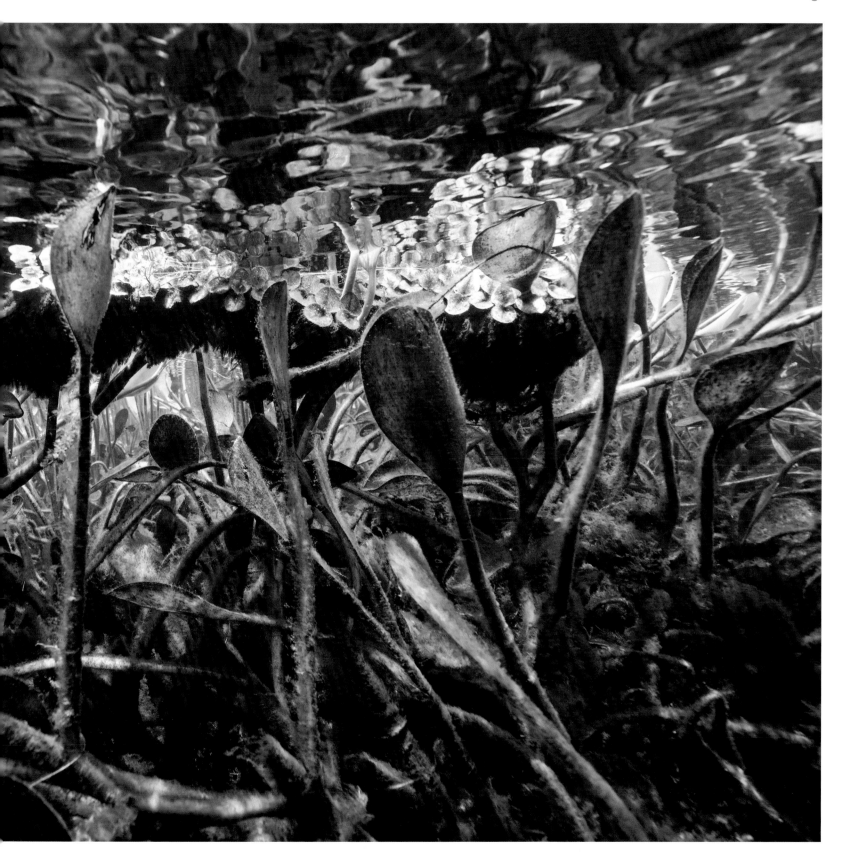

Layers of autumn
Uge Fuertes Sanz
SPAIN

Uge was drawn to the mountains around Albarracín in eastern Spain by the promise of aspens glowing with autumn colours. The trees didn't disappoint, but the show was stolen by a sea of teasels backlit in soft evening light. The name teasel derives from their spiny, egg-shaped seedheads, once used as combs to tease out the fibres of woollen cloth prior to spinning. These statuesque plants thrive in a wide range of habitats, from hedgerows and grassland to waste ground, especially where heavy soils have been disturbed. Teasels sport purple flowers in summer – attracting pollinators such as bees and long-tongued flies – followed by a bounty of seeds devoured by birds, notably goldfinches, through autumn and winter. Uge chose to focus on more distant teasels in the multitude, leaving those right in front blurred, while framing his shot to avoid any overlapping seedheads, near or far. The crimson of the aspens falls like a curtain behind, sealing the performance, leaving the audience wondering who the leading players are, as their eyes wander between the planes of focus.

Canon EOS 5D Mark III + Tamron 150–600mm f5–6.3 lens at 250mm; 1/800 sec at f5.6; ISO 640.

Sweet-grass and ripples
Theo Bosboom
THE NETHERLANDS

Theo had set out to photograph the forested mountain landscape surrounding a small lake in Björnlandet National Park, northern Sweden, but the blustery conditions ruined the reflections he had in mind. Frustrated, he went to explore the ancient pine forest, before returning past the lake. 'When I looked closer,' he says, 'I noticed the beautiful patterns created by the play of the wind, the waves, the grass and the reflections of the half-clouded sky.' Floating sweet-grass – typically found in marshes, in river margins and around lake shores – is a widespread and abundant species, tolerant of disturbance and high levels of nutrients. A creeping perennial with ribbon-like leaves that often float out over the water surface, it probably plays an important part in the gradual evolution of shallow, open water into grassland. Theo cast his eye around for a steady rock that would give him a high perspective near the water's edge. Earlier disappointment forgotten, he became absorbed in the ever-changing light and forms, glad of the chance to visualize this commonplace, often-overlooked subject as it swept elegantly to and fro in the flow of the water.

Canon EOS 5D Mark III + 70–200mm f2.8 lens at 125mm; 1/250 sec at f16; ISO 1000; Gitzo tripod + Really Right Stuff ballhead.

Saguaro twist

Jack Dykinga

USA

A band of ancient giants commands the expansive arid landscape of Arizona's Sonoran Desert National Monument in the US. These emblematic saguaro cacti – up to 200 years old – may tower at more than 12 metres (40 feet) but are very slow growing, some sprouting upwardly curved branches as they mature. The roots – aside from one deep tap – weave a maze just below the surface, radiating as far as the plant is tall, to absorb precious rainfall. Most water is stored in sponge-like tissue, defended by hard external spines and a waxy-coated skin to reduce water loss. The surface pleats expand like accordions as the cactus swells, its burgeoning weight supported by woody ribs running along the folds. But the saturated limbs are vulnerable to hard frost – their flesh may freeze and crack, while the mighty arms twist down under their loads. A lifetime of searching out victims near his desert home led Jack to know several that promised interesting compositions. 'This one allowed me to get right inside its limbs,' he says. As the gentle dawn light bathed the saguaro's contorted form, Jack's wide angle revealed its furrowed arms, perfectly framing its neighbours before the distant Sand Tank Mountains.

Nikon D810 + 14–24mm f2.8 lens at 14mm; 1/3 sec at f20; ISO 64; Really Right Stuff tripod.

Under Water

The jellyfish jockey

Anthony Berberian

FRANCE

In open ocean far off Tahiti, French Polynesia, Anthony regularly dives at night in water more than 2 kilometres (1¼ miles) deep. His aim is to photograph deep-sea creatures – tiny ones, that migrate to the surface under cover of darkness to feed on plankton. This lobster larva (on top), just 1.2 centimetres (half an inch) across, with spiny legs, a flattened, transparent body and eyes on stalks, was at a stage when its form is called a phyllosoma. Its spindly legs were gripping the dome of a small mauve stinger jellyfish. The pair were drifting in the current, the phyllosoma saving energy and possibly gaining protection from predators deterred by the jelly's stings, itself protected from the stings by its hard shell. The phyllosoma also seemed able to steer the jelly, turning it around at speed as it moved away from Anthony. The odd thing about the jelly was that it had few tentacles left, suggesting that the little hitchhiker was using it as a convenient source of snacks. In fact, a phyllosoma has a special digestion to deal with jellyfish stinging cells, coating them with a membrane that stops the stings penetrating its gut. In several hundred night dives, Anthony met only a few lobster larvae, and it took many shots of the jellyfish jockey to get a composition he was happy with – a portrait of a creature rarely observed alive in its natural surroundings.

Nikon D810 + 60mm f2.8 lens; 1/250 sec at f22 (−0.3 e/v); ISO 64; Nauticam housing + Nauticam SMC-1 super-macro converter; Inon Z-240 strobes.

Big sucker, little sucker

Alex Sher

USA

'The tricky part for the remora, and me,' says Alex, 'was staying close enough without being sucked in.' The whale shark, off the coast of the Maldives, was sucking in a huge cloud of krill (shrimp-like crustaceans), while a remora was picking them off from the passing stream. Unlike other species of remoras, this slender sharksucker – up to 1 metre (3 feet) long – often swims freely without a host, but it does associate with larger fish, especially sharks, eating their parasites as well as scavenging their prey. Whale sharks, the world's largest fish – this one being about 9 metres (29½ feet) long – live on plankton and small fish. Cruising slowly, often near the surface, they suck in water through their remarkably wide mouths and filter out prey as the water passes over their gills. Despite the closure of most commercial whale shark fisheries, this endangered species is still being caught to satisfy the demand for its meat and fins (mainly in Asia) and is also threatened by collisions with ships and entanglement in net fisheries.

Nikon D4 + 16mm f2.8 lens; 1/250 sec at f16; ISO 100; Nauticam housing; Ikelite DS160 strobes.

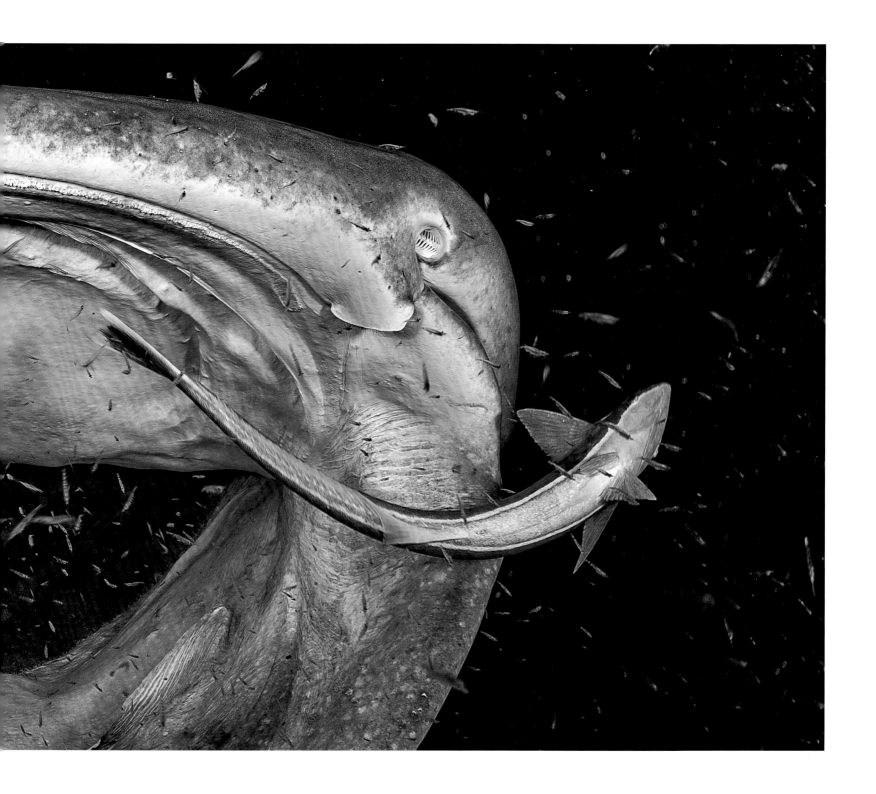

Rough love

Edwar Herreno

COLOMBIA/COSTA RICA

When Edwar spotted these guineafowl pufferfish off the northwest coast of Costa Rica, the large female was cowering in a crevice while a gang of amorous males tried to pull her out. These fish reach 50 centimetres (20 inches) long and, like other puffers, can inflate their abdomens with water to make themselves difficult for predators to swallow. The female was eventually dragged to mid-water. Her assailants – in two colour morphs, some yellow with few spots, but typically black with white spots (like guineafowl) – were intent on fertilizing her eggs. She tried desperately to escape, tugged by powerful jaws and teeth fused into beak-like plates. The males can rip her skin (see the bite marks behind her pectoral fins) and even kill her. Edwar captured the exhausted female's ordeal in the long mating prelude before she finally released her eggs.

Nikon D300 + Tokina 10–17mm f3.5–4.5 lens at 17mm; 1/125 sec at f8; ISO 200;
Sea & Sea housing; two Sea & Sea strobes.

Circle of life
Jordi Chias Pujol
SPAIN

A school of Atlantic horse mackerel bunch up as they are circled by predators, mostly European barracudas (striped) and bluefish. Jordi was looking for dolphins and whales around seamounts off the Azores when he got the tip-off – divers nearby had spotted birds gathering above the surface, signposting a swirl of activity beneath. The barracudas are skilful hunters of fish, as are the aggressive bluefish, which often attack shoals as well as hunting other animals such as squid. The baitball was 4–5 metres (13–16 feet) across, constantly moving and changing shape. 'It was so dense that I could put my hand inside and catch fish,' says Jordi. By swimming in a tight, coordinated school, the slender mackerel hoped to confuse their attackers, making it difficult for them to pick out individuals. In this case, the strategy seemed to work. Free-diving for a minute or two at a time, Jordi followed them for more than an hour and didn't see an attack. As the ball slowly managed to move deeper, he captured a top-down perspective of the life-and-death choreography.

Nikon D800 + 16mm f2.8 lens; 1/125 sec at f8 (−1 e/v); ISO 400; Isotta housing; Seacam strobes.

Spawn rivals

David Herasimtschuk

USA

In the shallows, cloaked in fallen leaves, two large male brook trout size each other up as they attempt to court the female between them. David had been daily scouting the Magalloway River in Maine, USA, for signs of the trout spawning, which they do every autumn in small streams and rivers across New England. Territorial disputes between two or more males are frequent and chaotic – rivals block, bite and ram each other – while the female gets on with digging a nest (a redd) in the gravel, where she will lay her eggs. David often broke through surface ice to lie motionless for hours in the freezing water, allowing the fish to get used to his presence. On a breezy day, tumbling leaves were swept against the bank above one female's nest. David eventually got close enough to capture the rivalry between her finely patterned suitors, revealing the autumn hues hidden under water. This North American trout, with its distinctive white-edged fins, is in decline, largely due to habitat loss and degradation, but collaborative conservation efforts, which David supports with his images, aim to curb this.

Sony A7RII + 28mm f2 lens + Nauticam WWL-1 lens; 1/60 sec at f7.1; ISO 2000; Nauticam housing; two Inon strobes.

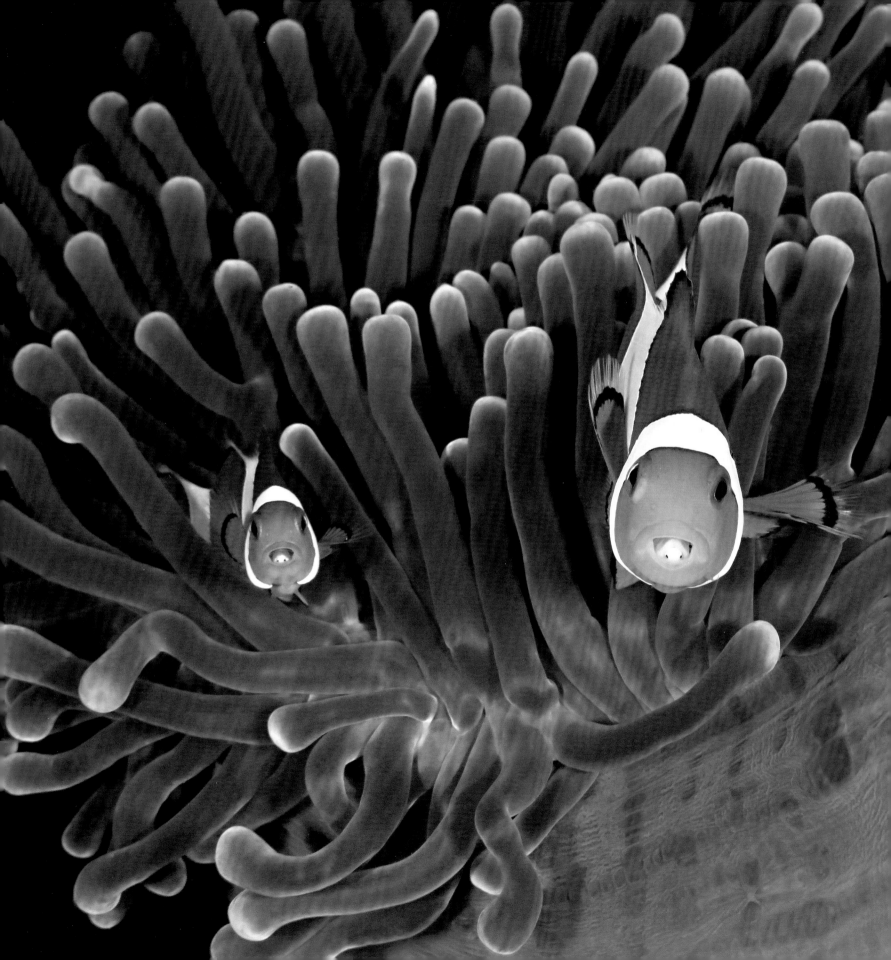

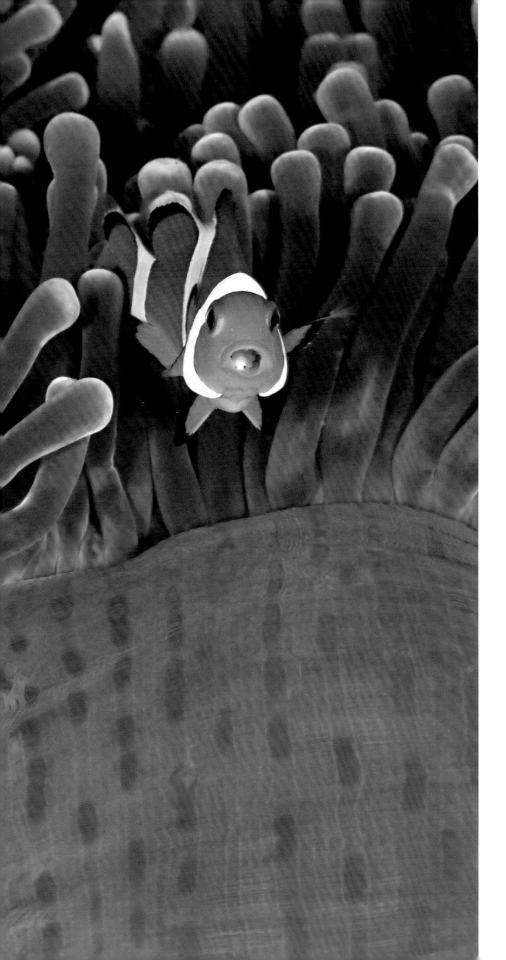

The insiders
Qing Lin

CHINA

The bulbous tips of the aptly named magnificent anemone's tentacles contain cells that sting most fish. But the clown anemonefish goes unharmed thanks to mucus secreted over its skin, which tricks the anemone into thinking it is brushing against itself. Both species benefit. The anemonefish gains protection from its predators, which daren't risk being stung, and it also feeds on parasites and debris among the tentacles; at the same time, it improves water circulation (fanning its fins as it swims), scares away the anemone's predators and may even lure in prey for it. While diving in the Lembeh Strait in North Sulawesi, Indonesia, Qing noticed something strange about this particular cohabiting group. Each anemonefish had an extra pair of eyes inside its mouth – those of a parasitic isopod (a crustacean related to woodlice). An isopod enters a fish as a larva, via its gills, moves to the fish's mouth and attaches with its legs to the base of the tongue. As the parasite sucks its host's blood, the tongue withers, leaving the isopod attached in its place, where it may remain for several years. With great patience and a little luck – the fish darted around unpredictably – Qing captured these three rather curious individuals momentarily lined up, eyes front, mouths open and parasites peeping out.

Canon EOS 5D Mark III + 100mm f2.8 lens; 1/200 sec at f25; ISO 320; Sea & Sea housing; two Inon strobes.

Wildlife Photojournalist: Single image

Palm-oil survivors

Aaron 'Bertie' Gekoski

UK/USA

In eastern Sabah, on the island of Borneo, three generations of Bornean elephants edge their way across the terraces of an oil-palm plantation being cleared for replanting. Palm oil is a lucrative global export, and in the Malaysian state of Sabah, where the majority of rainforest has already been logged (only 8 per cent of protected intact forest remains), the palm-oil industry is still a major driver of deforestation, squeezing elephants into smaller and smaller pockets of forest. Increasingly they wander into oil-palm plantations to feed, where they come into conflict with humans, with elephants being shot or poisoned. (In 2013, poison used in a plantation killed a herd of 14 elephants – the sole survivor, a calf, was found caressing its dead mother.) Reports of elephant attacks on humans are also on the rise. Today, the fragmented population of Bornean elephants – regarded as a subspecies of the Asian elephant that may have been isolated on the island of Borneo for more than 300,000 years – is estimated to number no more than 1,000–2,000. Elephants form strong social bonds, and females often stay together for their entire lives. Here, the group probably comprises a matriarch, two of her daughters and her grand-calf. With the light fading fast, Bertie acted quickly to frame an image that symbolizes the impact that our insatiable demand for palm oil (used in half of the products on supermarket shelves) has on wildlife. 'They huddled together, dwarfed by a desolate and desecrated landscape. A haunting image,' he says.

Nikon D700 + 80–200mm f2.8 lens at 120mm; 1/500 sec at f3.2; ISO 400.

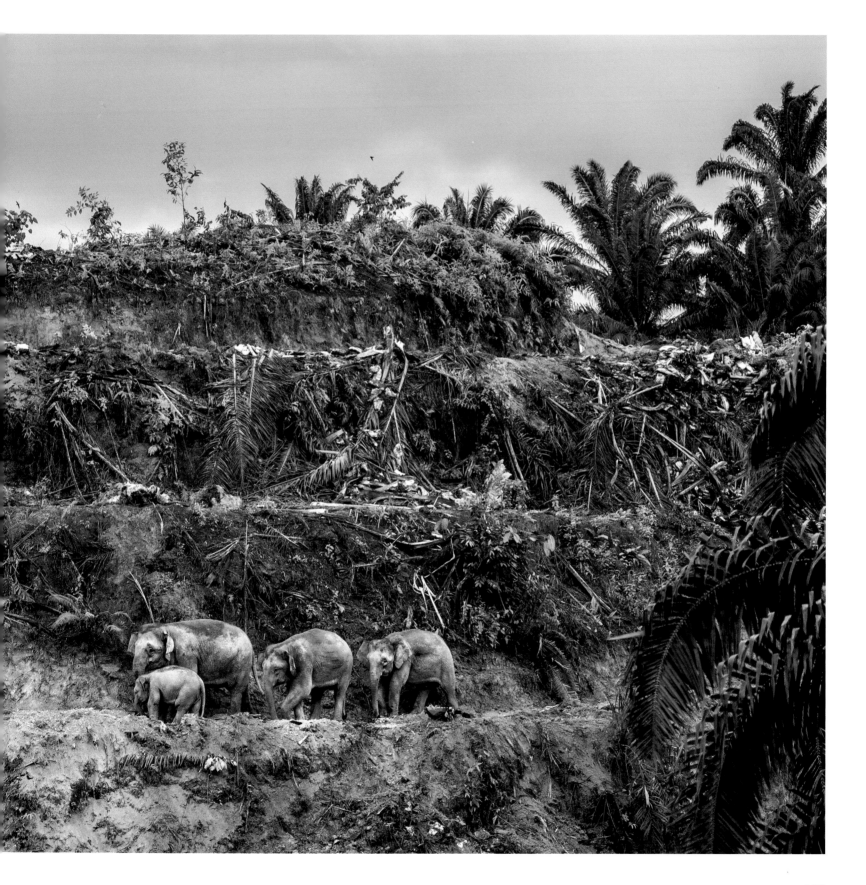

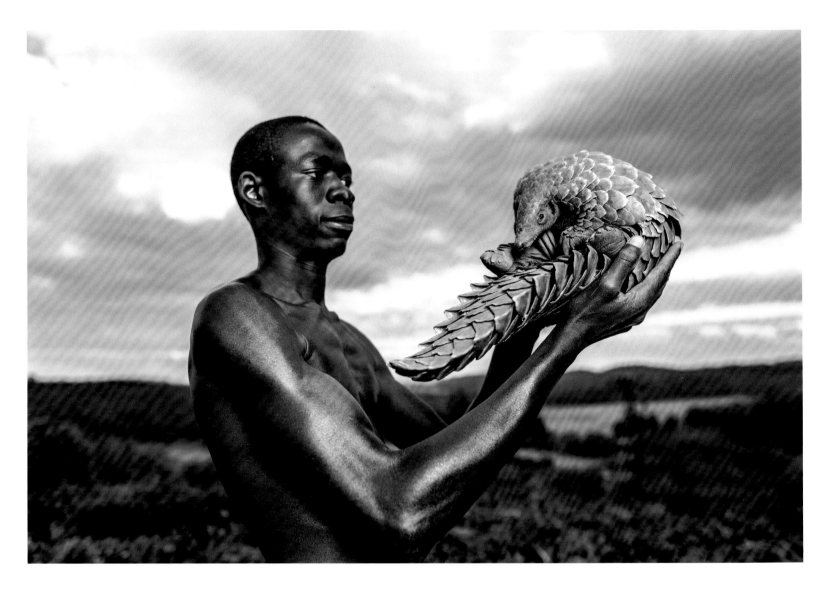

Saved by compassion
Adrian Steirn

AUSTRALIA

When threatened, a pangolin rolls into a tight ball. The fact that this Temminck's ground pangolin is unrolled and relaxed in the hands of its carer shows the bond between them. Having been confiscated from poachers, it is recovering at the Tikki Hywood Trust, a rehabilitation centre in Zimbabwe. Pangolins are the most trafficked mammals in the world. In spite of a global ban on their trade, their scales, meat and blood continue to be sold on the Asian black market. With all four Asian species now endangered or critically endangered, poachers are turning their attention to the four African ones. For those pangolins lucky enough to be rescued, rehabilitation is a long, labour-intensive process. This carer looks after his charge 24 hours a day, carrying it around and even settling it to sleep. Then, once it has reached a healthy weight, it will be taken to a monitored location and released.

Leica S (Typ 007) + 30mm lens; 1/250 sec at f2.8; ISO 100; Profoto flash.

Handled with care
Robin Moore
UK

A field technician cradles Jamaican iguana hatchlings he has just gently scooped out of a nest in the remote Hellshire Hills of Jamaica's Portland Bight Protected Area. The babies, just hours old, will be transferred to Hope Zoo in Kingston. They will live in captivity for a few months as part of a 'head start' initiative until they are no longer vulnerable to predation by introduced species such as the Indian mongoose. Then they will be released. This native lizard, once common in Jamaica, was thought to have become extinct in the 1940s. Then, in 1990, a small population of fewer than 100 was discovered, and an intensive and successful effort was launched to reintroduce the Jamaican iguana. In 2013, the government revealed plans to develop a massive transhipment port that would rip the Jamaican iguana's tropical dry-forest home apart and put the reptile's comeback in jeopardy. A second campaign (supported by images such as this one) eventually persuaded the Prime Minister to rethink. And in 2016, the government announced that it had decided to build the port elsewhere, averting an environmental crisis – the local marine environment would also have been destroyed – and saving one of the world's rarest lizards.

Canon EOS 5D Mark III + 100mm f2.8 lens; 1/200 sec at f5.6; ISO 160; 600EX II-RT + two 580EX Speedlight flashes; Westcott 28" Apollo umbrella-style softbox.

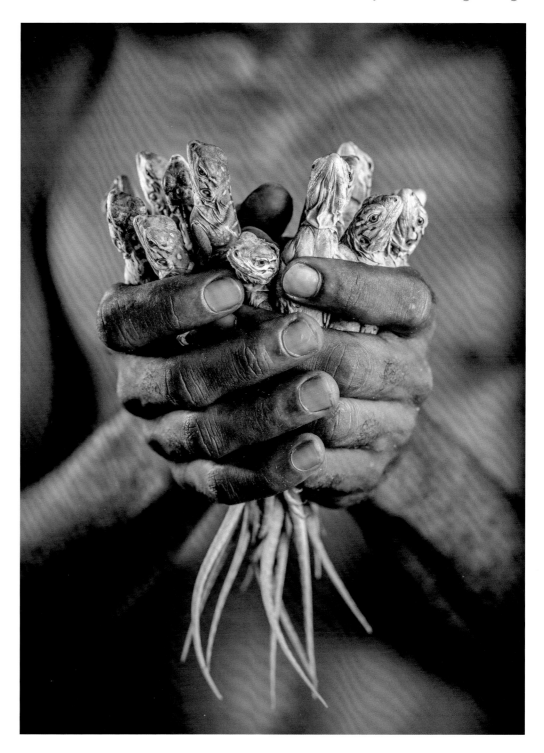

Saved but caged
Steve Winter

USA

A back leg of this six-month-old Sumatran tiger cub was so badly mangled by a snare that it had to be amputated. He was lucky to survive at all, having been trapped for four days before being discovered in a rainforest in Aceh Province on the Indonesian island of Sumatra. The likelihood is that the snare was set by oil-palm plantation workers to catch bushmeat (though tigers are also deliberately snared). The workers are migrants who have been given small plots to grow their own oil palms but who have to work on the big plantations for about five years until their own crops generate a return. To feed their families, they have to hunt, and this cub's bones would have fetched a good price on the black market. The population of Sumatran tigers, a subspecies, is as low as 400–500 (the world population of all wild tigers is no more than than 3,200) – the result of poaching to fuel the illegal trade in tiger parts for the Chinese-medicine market. Anti-poaching forest patrols are helping to stem the killing, partly by locating and removing snares (now illegal), which is how this cub came to be rescued. The cub, however, will spend the rest of his life in a cage in a Javan zoo. Today, there are probably more Sumatran tigers in zoos than there are left in the wild.

Canon 5D Mark II + 24–105mm lens at 58mm; 1/45 sec at f5.6; ISO 400.

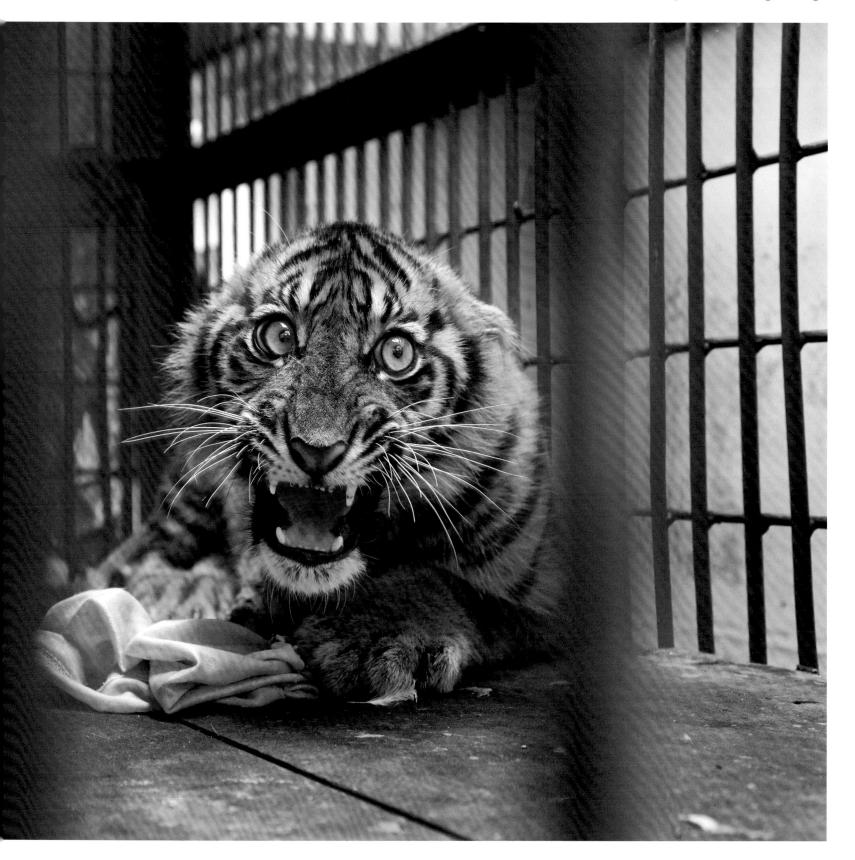

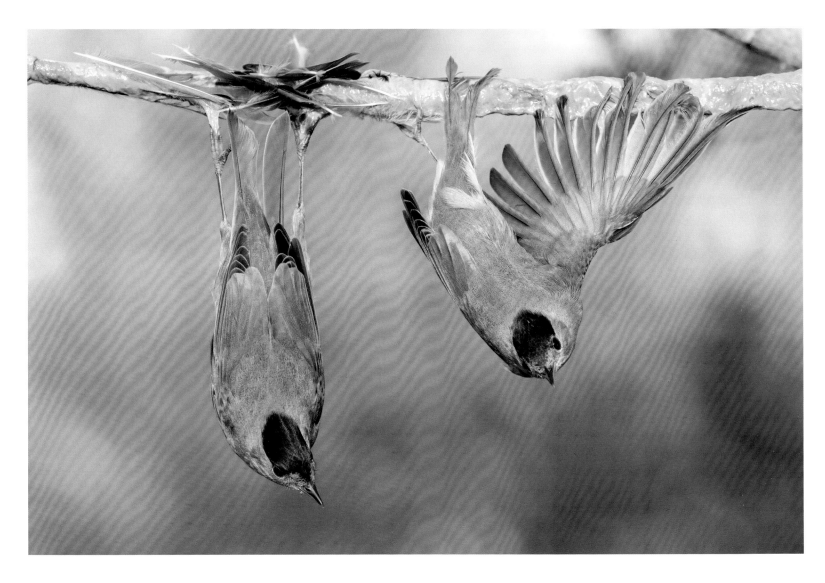

The bird rack

Bence Máté

HUNGARY

About to be rescued, these two blackcaps are the lucky ones. As they pass over Cyprus on migration, blackcaps and other songbirds – including chaffinches, robins and warblers – are lured down with recorded birdsong and trapped in 'mist' nets (the British military base is a trapping hotspot) or, as here, with limesticks – sticky perches placed in trees. More than two million protected birds are caught every year for Cyprus's gastronomic black market. Poor law enforcement means that poachers, dealers and restaurants serving ambelopoulia, the illegal passerine delicacy that fuels this slaughter, are rarely punished, as Bence saw when he joined a Committee Against Birds Slaughter anti-poaching camp. 'In cooperation with the police, we caught poachers every day, all of whom were released without punishment.' In the Mediterranean, an estimated 25 million birds of at least 150 species are killed on migration. 'It's one of the biggest conservation failures of our time,' says Bence.

Canon EOS-1DX + 200–400mm f4 lens; 1/1000 sec at f8; ISO 2000.

Children of the rainforest
Charlie Hamilton James

UK

Yoina, age nine, skipped through Charlie's camp on her way to the river with her pet saddle-back tamarin. Yoina is a member of the Machiguenga (Matsigenka), an indigenous hunter-gatherer community of around 1,000 people who live in Yomibato, a remote area of Peru's Manú National Park. As well as growing a few crops and gathering plants for food and medicine, they also have the right to hunt animals (without guns, for their own use) including monkeys. When monkeys carrying young are killed, the babies are often kept as pets, sometimes to be released when they're older. Every day, Yoina would go for a swim, taking the tamarin with her. 'I have no idea why she did this. The tamarin hated it and spent the whole time screaming and trying to clamber onto her head to escape the water,' says Charlie. He was covering the story of the relationship between humans and wildlife in Manú, one of the most biodiverse places on Earth. Here people consider themselves as part of nature, not separate from it, but their future, like that of the park, is uncertain. Not long after this picture was taken, life took a tragic turn for both subjects. The tamarin died after pulling a pot of boiling water onto itself, and a few weeks later, Yoina's mother died in childbirth.

Canon EOS-1DX + 85mm f1.2 lens; 1/640 sec at f1.4; ISO 200.

Sewage surfer
Justin Hofman

USA

Seahorses hitch rides on the currents by grabbing floating objects such as seaweed with their delicate prehensile tails. Justin watched with delight as this tiny estuary seahorse 'almost hopped' from one bit of bouncing natural debris to the next, bobbing around near the surface on a reef near Sumbawa Island, Indonesia. But as the tide started to come in, the mood changed. The water contained more and more decidedly unnatural objects – mainly bits of plastic – and a film of sewage sludge covered the surface, all sluicing towards the shore. The seahorse let go of a piece of seagrass and seized a long, wispy piece of clear plastic. As a brisk wind at the surface picked up, making conditions bumpier, the seahorse took advantage of something that offered a more stable raft: a waterlogged plastic cotton bud. Not having a macro lens for the shot ended up being fortuitous, both because of the strengthening current and because it meant that Justin decided to frame the whole scene, sewage bits and all. As Justin, the seahorse and the cotton bud spun through the ocean together, waves splashed into Justin's snorkel. The next day, he fell ill. Indonesia has the world's highest levels of marine biodiversity but is second only to China as a contributor of marine plastic debris – debris forecast to outweigh fish in the ocean by 2050. On the other hand, Indonesia has pledged to reduce by 70 per cent the amount of waste it discharges into the ocean.

Sony Alpha 7R II + 16–35mm f4 lens; 1/60 sec at f16; ISO 320; Nauticam housing + Zen 230mm Nauticam N120 Superdome; two Sea & Sea strobes with electronic sync.

Wildlife Photojournalist Award

This award is given for a story told in just six images, which are judged on their storytelling power as a whole as well as their individual quality.

Brent Stirton

SOUTH AFRICA

RHINO HORN: THE ONGOING ATROCITY

This is a follow-up to Brent Stirton's 2012 investigation of the illegal international trade in rhino horn. It's a trade fuelled by ever-increasing demand for horn in Asia – China and Vietnam principally – where there is a long-held belief that it has medicinal value. Four years later, he found trade involving criminal syndicates and horn with a street value higher than gold or cocaine. In Vietnam, rising wealth has coincided with a reinforced belief, that rhino horn – the same material as toenails – can cure everything from cancer to kidney stones. All of the world's rhino species are targets for poaching, but since South Africa has about 80 per cent of the remaining rhinos, that is where most have been killed – more than 1,000 a year since 2013, with insider sources saying as many as 1,500. There is hope, if countries such as China could take the lead, but there are also powerful enemies in corruption, greed and, above all, ignorance.

Memorial to the species

The killers were probably from a local community but working to order. Entering the Hluhluwe Imfolozi Park at night, they shot the black rhino bull using a silencer. Working fast, they hacked off the two horns and escaped before being discovered by the reserve's patrol. The horns would have been sold to a middleman and smuggled out of South Africa, probably via Mozambique, to China or Vietnam. For the reserve, it was grim news, not least because this is where conservationists bred back from near extinction the subspecies that is now the pre-eminent target for poachers, the southern white rhino. For the photographer, the crime scene was one of more than 30 he visited in the course of covering this tragic story.

Canon EOS-1DX + 28mm f2.8 lens; 1/250 sec at f9; ISO 200; flash.

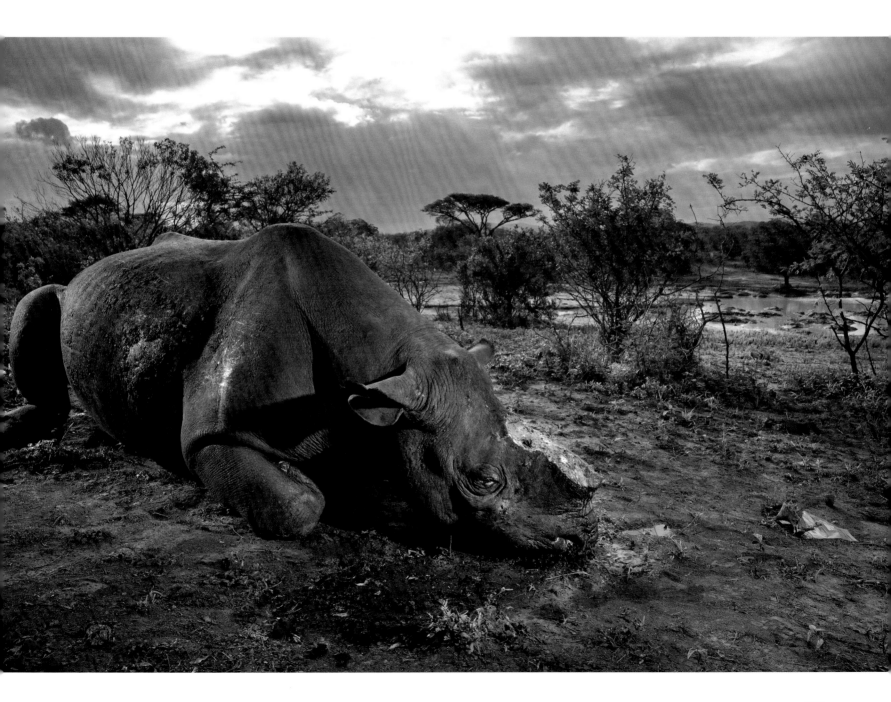

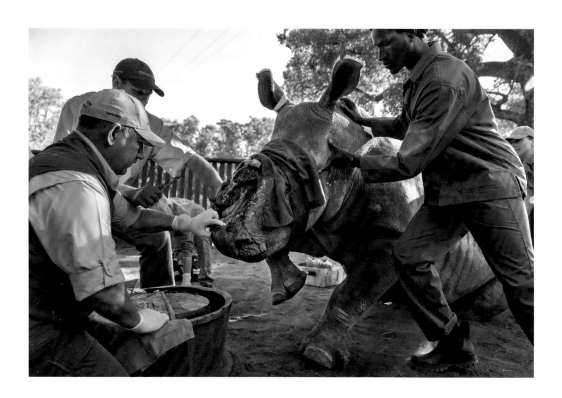

Saving Hope

Vets attend to a gaping wound on a female white rhino found hiding in the South African bush in April 2015. Five nights before, poachers had darted her and cut off her horns, along with much of her face. Given the name Hope, she was brought to Saving the Survivors, a South African charity run by veterinary surgeons caring for endangered animals. Hope underwent 16 surgical procedures, and because the poachers had removed so much bone, a base for a protective shield had to be drilled onto her. As the enormous wound began to heal, the challenge was to keep it covered – each attempt was thwarted by a spirited, 2-tonne animal determined to scratch an itch. The team experimented with elastic shields made of skin and, eventually, a Canadian material developed for use in abdominal surgery. By September 2016, Hope was recovering well, but in November she died suddenly from an intestinal infection. Her devastated carers describe her legacy as increased expertise in treating brutal wounds and drawing worldwide attention to the plight of rhinos.

Canon EOS-1DX + 24mm lens; 1/200 sec at f3.2; ISO 200.

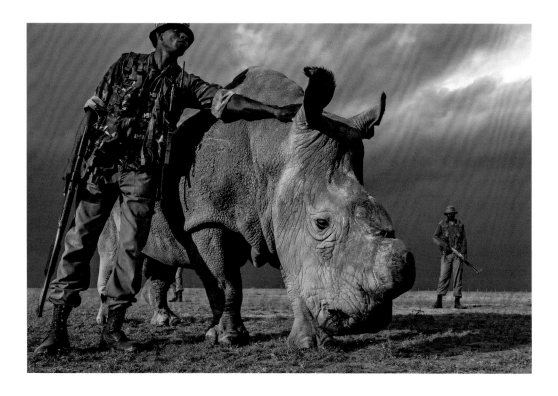

Last of a kind

Armed guards in Kenya's Ol Pejeta Conservancy keep a 24-hour watch over three northern white rhinos – the last of their kind. The guards all speak of their deep sense of vocation and the close relationship they have developed with their charges. Northern white rhinos, a subspecies of white rhino, though considered by some as a full species, once ranged over an area of central Africa, but years of poaching and civil wars decimated the populations until, by 2006, there were no signs of them in the wild. These three are the last captive animals, all from a zoo in the Czech Republic, including (here) 43-year-old Sudan, the last male. All hope that the climate of their native habitat would help them breed has evaporated, though scientists are exploring the possibility of using stem-cell technology to save their genes. But even if it proved possible to engineer offspring, they would be badly inbred, and if the desire for rhino horn remains, there is no guarantee they wouldn't go the way of their wild relatives.

Canon EOS 5D + 35mm f1.4 lens; 1/250 sec at f8; ISO 100.

Caring for Lulah

Full-time caregiver Dorota Ladosz comforts Lulah, an orphaned black rhino, after an operation to clean a leg infection. Lulah was found by rangers after her mother had been killed by poachers in Kruger National Park, South Africa's largest wildlife reserve. Hyenas had attacked the one-month-old calf, chewing off her ears and parts of her nose and severely injuring a rear leg. The rangers brought her to the safety of Care for Wild Africa, a rhino orphanage run by a small team assisted by volunteers from around the world. Dorota was appointed to look after Lulah, keeping watch on her injuries, feeding her, taking her temperature and sleeping beside her. Care for Wild Africa has become the largest rhino sanctuary in the world – at the date of this photograph, caring for 27 rhino orphans, all victims of the unprecedented levels of poaching in South Africa. A rhino calf has a strong bond with its mother, and though weaned at 18 months, it will stay with her for up to three years. All the orphans had been present when their mothers were killed, and many were also attacked by the poachers, often with machetes.

Canon EOS-1DX + 28mm f2 lens; 1/125 sec at f2.8; ISO 3200; flash.

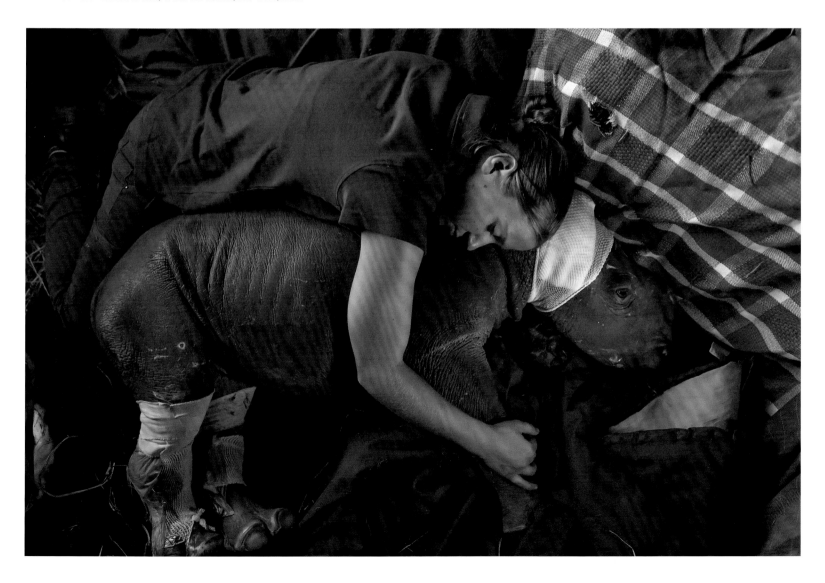

The rhino-horn farmer

South African Dawie Groenewald poses at his game farm in Limpopo province, where he breeds valuable wild animals for sale and hunting. He is the subject of a six-year-long court case involving charges relating to illegal rhino handling, horn theft and money laundering. He has also been arrested in the US on animal-trophy charges. Groenewald denies any wrongdoing. Together with John Hume, who farms more than 1,400 rhinos and has the world's largest stockpile of horn, he has been one of the driving forces behind efforts to legalize trade in rhino horn. They argue that farming rhino for their horns, which regrow, could depress prices and supply the demand without any animals having to be killed. Conservation organizations counter that a legal trade would stimulate demand and become a mechanism for even more poached horn to be traded. In April 2017, John Hume and Johan Kruger won a legal case to allow internal trade of horn in South Africa. Though the ban on international trade remains, conservationists fear that the internal trade will allow illegal horn to be passed off as legal. The debate continues, as does the poaching.

Canon EOS-1DX + 35mm f1.4 lens; 1/250 sec at f2.8; ISO 800.

Point of sale

Rubbing rhino horn against a specially surfaced bowl, then mixing in water, a traditional-medicine specialist in Vietnam prepares a potion for his client. Horn is used for many ailments including kidney stones and fevers as well as to enhance sexual prowess. This client has breast cancer and has been told that rhino horn can cure her. Cancer is not traditionally treated with rhino horn, but prominent Vietnamese vouching for its efficacy have fuelled a surge in demand, pushing prices ever higher. Its sale is illegal in Vietnam, just as exporting it is illegal in South Africa, but it is readily available. The main consumers are wealthy men who take it as a display of prestige and power, but many people keep a stock in case of illness. Brent went under cover in Vietnam to photograph this phenomenon. Some people understand that rhinos are threatened species, he says, but if they are desperately ill, that outweighs all other concerns. He concludes that the responsibility lies with the country's leaders to curtail this growing trend. Meanwhile, the dovetailing of ancient traditions with contemporary fashion drives another species to extinction.

Fuji FinePix X100 + 35mm f2 lens; 1/210 sec at f4; ISO 640.

Wildlife Photojournalist Award

Stefano Unterthiner

ITALY

SAVING YAKI

The Sulawesi crested black macaque, known locally as the yaki, is native only to the Indonesian island of Sulawesi. Critically endangered through hunting, the live-animal trade and forest clearance, its population has fallen by 90 per cent in 30 years. Aware of the crisis since his first visit in 2007, Stefano Unterthiner undertook a two-month investigation last year into the relationship between macaques and people. He found the bushmeat market a 'nightmare of blood and burnt animals' and the yaki's story one that had to be told if the species was to be saved.

Last glance

Every day for several weeks, Stefano followed a large group of about 80 Sulawesi crested black macaques through the island's Tangkoko Nature Reserve, accompanying primate researchers observing this 'little society'. Backlit by the last of the daylight, this male glanced at Stefano, just before moving away with the rest of the group to a sleeping area in a big tree nearby.

Nikon D4S + 300mm f4 lens; 1/320 sec at f4; ISO 2000.

Portrait of Nona

It took several weeks before Stefano found the opportunity he had been looking for to illustrate the pet trade. He made several visits to this family before he felt the time was right to photograph Nona – meaning 'miss' – their pet Sulawesi crested black macaque. It was the early morning, and the owner stood relaxed in the sunshine as Stefano photographed the poignant scene – the shadow of Nona, her chain and the tree symbolizing the loss of forest and freedom. It is illegal to keep this critically endangered species in captivity, but though the practice is no longer widespread, the law is rarely enforced, particularly in remote areas. If a pet monkey is confiscated, it can be easily replaced. Local people enjoy the endearing babies – usually adopted after killing a mother for the pot – but they are often malnourished and are kept chained or in cramped conditions. And as they get bigger and less manageable, they may well be sold for meat.

Nikon D4S + 16–35mm f4 lens; 1/1000 sec at f8; ISO 1250.

No man's land

Sulawesi crested black macaques search for food in the burnt land that was once secondary forest on the outskirts of Sulawesi's Tangkoko Nature Reserve, and close to a village plantation of coconuts and mangoes. The fire, which destroyed large areas inside and outside the reserve, was in part a result of the 2015 drought that affected most of Indonesia and led to massive forest fires. But fires are also deliberately lit and the forest chipped away at for crop-planting. As the forest shrinks, so does the feeding area for the macaques, which are now venturing into the villages and plantations, where they risk being killed by villagers who want to protect their plantations.

Nikon D4S + 16–35mm f4 lens at 24mm; 1/200 sec at f9; ISO 1000.

A vision of self

A small road cuts through the Sulawesi crested black macaque's forest reserve, used by people from the nearby village as well as researchers and tourists. Scooters – the main mode of transport in the area – are often parked along the road, and it is not uncommon to see a macaque on one peering at itself in the mirror, as in the case of this male. Indeed, locals fold down their mirrors to avoid attracting the monkeys. Primate communication is all about facial expression, and Stefano was fascinated by the macaque's curiosity. Did he know he was seeing himself when he made faces, or was he merely intrigued by the monkey in the mirror? Great apes can recognize themselves in mirrors. So it's not inconceivable that macaques can, too.

Nikon D4S + 300mm f4 lens; 1/320 sec at f4; ISO 2000.

A taste of humanity

Heading along the beach on his way to the forest, Stefano passed a family picnic and noticed that there were extra guests hanging around – a group of Sulawesi crested black macaques had spotted the opportunity for handouts. It was a relaxed situation, and one man held out his cup of coffee for the boldest male to investigate. One sniff and the macaque was unimpressed and moved off into the forest. Feeding macaques, or any wildlife, is forbidden, and rangers and guides will warn people of the risk of being bitten – if one macaque gets excited by the promise of food, others will gather and can become agitated and aggressive. There is also the risk of disease transmission – in either direction. Locals don't normally feed their primate neighbours, and the likelihood is that these people were from the city, encountering wild macaques maybe for the first time.

Nikon D4S + 16–35mm f4 lens; 1/160 sec at f8; ISO 1600.

Where yakis end up

Dealer and hunter Nofi Raranta prepares bushmeat for sale at the market. In the wheelbarrow is Sulawesi warty pig – an increasingly rare wild pig found only in Indonesia – and propped up against the wall is a Gorontalo macaque. Nofi may also have had yaki meat in the freezer – meat from the Sulawesi crested black macaque – a delicacy at weddings and festivals in this part of the island, where Christians are the majority. But now yakis are scarce, other macaque species are taking their place and will soon become endangered, too. When Stefano began investigating the bushmeat trade, he was advised to look for macaque meat in the markets at Christmas and Easter, but in some remote areas, he found it available all the time. Selling it is illegal, but there are no police and no fear of prosecution, though it did take two months to get access to Nofi at his home. If there were consequences for Nofi as a result of this image, they would be minimal, says Stefano: 'I feel sympathy for Nofi, but he needs to sell something else. This killing of critically endangered species has to stop.'

Nikon D4S + 16–35mm f4 lens; 1/160 sec at f6.3; ISO 1600.

The Young Wildlife Photographer of the Year 2017

The Young Wildlife Photographer of the Year 2017 is

Daniël Nelson – the winning photographer whose picture has been judged to be the most memorable of all the pictures by photographers aged 17 or under.

Daniël Nelson

THE NETHERLANDS

It was at age six, on a family trip to Zambia, that Daniël first held a camera and realized he could create his own pictures. Growing up in Amsterdam but being lucky enough to travel, he has retained his passion for wildlife photography and built up a portfolio of work. His award-winning image was taken when he was 16. Now that he's left school, he's off backpacking across Africa – a 'first milestone in my career as a photographer'.

WINNER (15–17 YEARS OLD)

The good life

Daniël met Caco in the forest of Odzala National Park in the Republic of Congo. A three-hour trek through dense vegetation with skilled trackers led him to where the 16-strong Neptuno family was feeding and to a close encounter with one of the few habituated groups of western lowland gorillas. In the wet season they favour the plentiful supply of sweet fruit, and here Caco is feasting on a fleshy African breadfruit. Caco is about nine years old and preparing to leave his family. He is putting on muscle, becoming a little too bold and is often found at the fringe of the group. He will soon become a solitary silverback, perhaps teaming up with other males to explore and, with luck, starting his own family in eight to ten years' time. Western lowland gorillas are critically endangered, threatened by illegal hunting for bushmeat (facilitated by logging and mining roads), disease (notably the Ebola virus), habitat loss (to mines and oil-palm plantations) and the impact of climate change. In his compelling portrait of Caco – relaxed in his surroundings – Daniël captured the inextricable similarity between these wild apes and humans and the importance of the forest on which they depend.

Canon 6D + Sigma 50–500mm f4.5–6.3 lens at 500mm; 1/30 sec at f6.3; ISO 800.

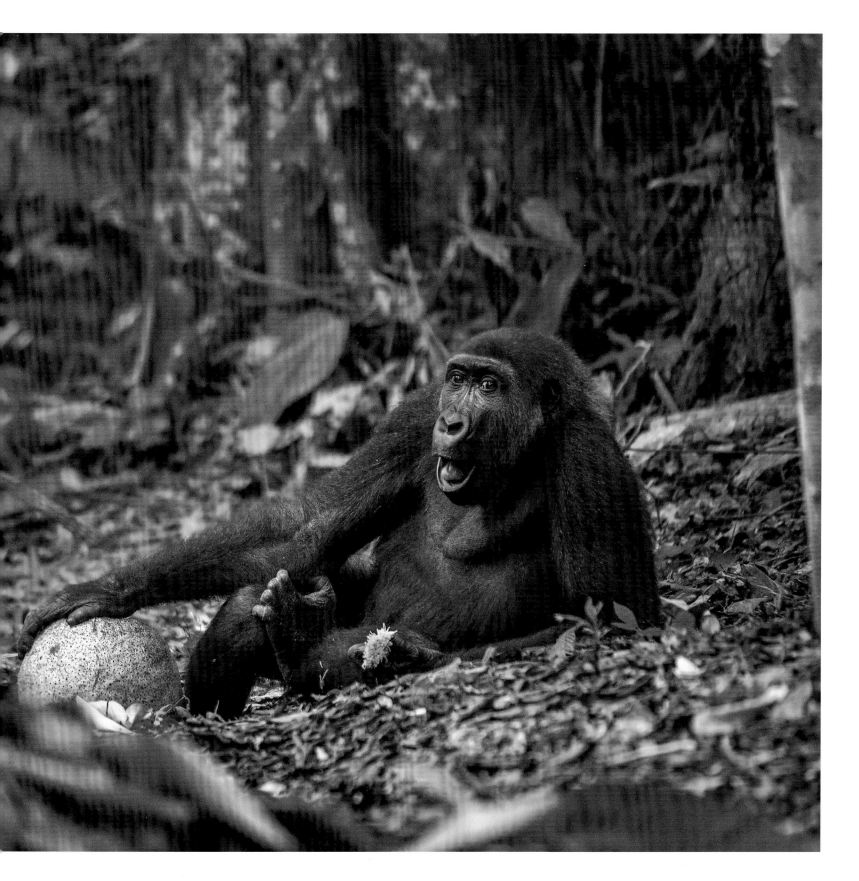

Boar crossing

Marc Albiac

SPAIN

From the car window, the winding curves of the road caught Marc's eye and gave him an idea. He had been watching wild boar in Viladecavalls, near Barcelona, Spain, and knew that to get to the town from the forest, they had to cross this road. Though wild boar eat mainly fruit, seeds, roots and tubers, they are omnivorous, and in the town, cat food is on offer. Usually most active in the early morning and late afternoon, the adaptable boar – with one of the widest distributions of all land mammals – becomes nocturnal in disturbed areas. Boars travel over distances, foraging for four to eight hours a night. Marc framed his shot with the road snaking away under the glow of the street lights – a scene that would depict the coexistence of wildlife and people. Luck was with him when a mother and her two piglets crossed dutifully at the zebra crossing, adding the finishing touch to his composition.

Canon EOS 5D Mark III + 100mm f2.8 lens; 1/25 sec at f2.8; ISO 6400; Manfrotto tripod.

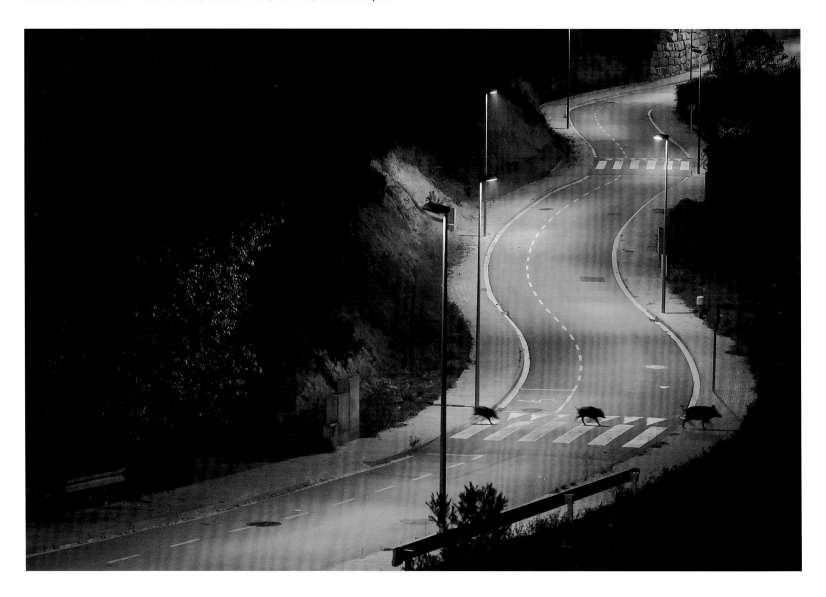

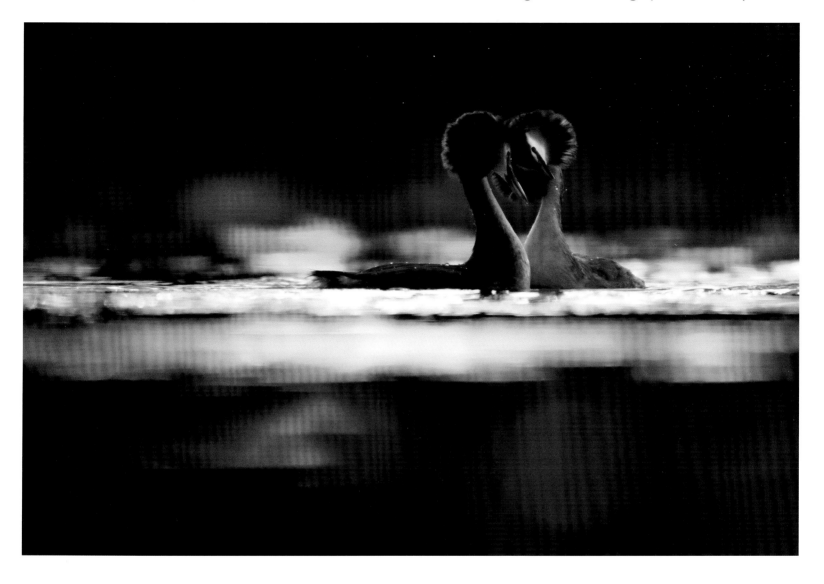

An elegant affair
Knut Erik Alnæs
NORWAY

The mesmerizing ballet of courting great crested grebes had long fascinated Knut Erik, and night after night he lay in the mud beside Lake Østensjøvannet in Oslo, Norway, determined to capture their elegance. The light was exquisite and the dancers performed – rising up breast to breast and turning their heads from side to side – but they were always in the wrong place, behind plants or in darkness. On his fifth and last night, for just a few seconds, the two birds united in clear view, shaking their heads ceremonially, as the last rays of light caught their outstretched head plumes against the dark woods behind. Despite hours of discomfort lying still, Knut Erik was ready to act, capturing the emotion of their graceful tango without disturbing the couple. Two minutes later, the light was gone.

Canon EOS 5D Mark III + 400mm f2.8 lens + 2x extender; 1/2500 sec at f5.6 (−0.3 e/v); ISO 1600.

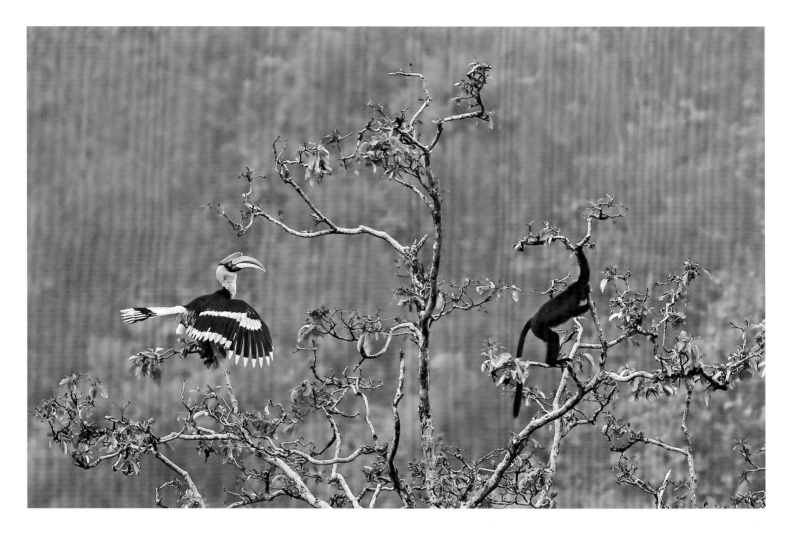

Hornbill losing patience

Dhanu Paran

INDIA

Perched on a hillside in the Anaimalai Hills in India's Western Ghats, Dhanu was watching great hornbills when a little drama started to unfold. One hornbill was preening in a treetop when a Nilgiri langur climbed up and sat opposite it. At first it just watched the giant bird, but then it started to hassle it. As the hornbill flapped its annoyance, the langur retreated. Dhanu framed the interaction, capturing the bird with its wings outstretched – wings so big that they make a loud 'whooshing' noise when it flies. Obsessed with great hornbills, Dhanu has discovered where they congregate and treks to see them as often as possible – 22 kilometres (14 miles) from his home, across tea plantations and forest, facing elephants and Indian bison along the way. Great hornbills prefer forest with large trees, because they need tree cavities to nest in, and as fruit-eaters, they play an important role in seed dispersal. The distinguishing hollow casques are used in spectacular aerial 'casque-butting' contests and, presumably, they make the huge curved beaks look even more threatening – useful for getting rid of annoying monkeys.

Canon EOS 7D Mark II + 100–400mm f4.5–5.6 lens at 400mm; 1/8000 sec at f6.3 (–1 e/v); ISO 1250.

Alfred in contemplation
Russell Laman

USA

Though they're the world's largest arboreal animals, orangutans are difficult to track. They travel through the trees in dense rainforest, and 'if they do come to the ground,' says Russell, 'they can run through the underbrush faster than any human.' He should know. Every year, he visits his mother's orangutan research programme in Borneo, in Indonesia's Gunung Palung National Park. It's one of the last strongholds of Bornean orangutans, which face multiple threats, including forest clearance for oil-palm plantations, pulpwood concessions and agriculture, and lack of legal protection. Bornean orangutans are critically endangered, with possibly fewer than 50,000 left in the wild. Russell had been tracking a female when he heard a loud crash – Alfred suddenly appeared and swung down through the trees to pick some choice leaves, giving Russell a rare chance to see him clearly. 'As Alfred gazed off into the distance, I couldn't help wonder what he was thinking.'

Canon EOS 7D + 70–200mm f2.8 lens; 1/250 sec at f2.8 (–0.5 e/v); ISO 800.

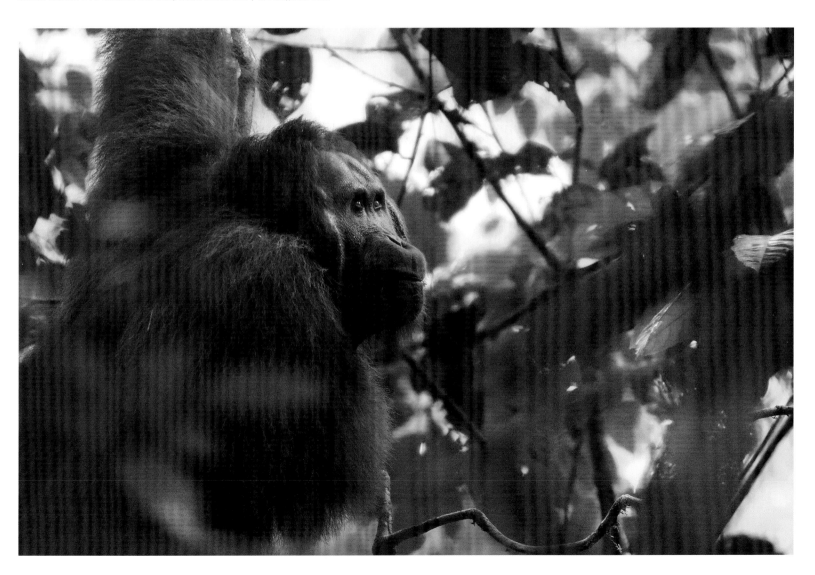

Young Wildlife Photographers: 11–14 years old

Stuck in
Ashleigh Scully

USA

Deep snow had blanketed the Lamar Valley in Yellowstone National Park, and the day was cold and overcast. This female American red fox was hunting beside the road, stepping quietly across the crusty surface of the snow. Every so often she would stop, stare, tilt her head from side to side and listen intently for the movement of prey – most likely a vole – beneath the snow. Ashleigh was also poised, her camera lens resting on a beanbag out of the back window of the car. Just as the fox came parallel with the car, she stopped, listened, crouched and then leapt high in the air, punching down through the snow, forefeet and nose first and legs upended. She remained bottom-up for about 10 seconds, waving her tail slightly back and forth before using her back legs to pull out of the hole. Ashleigh, who has been photographing foxes for many years, though mostly near her home, captured the whole sequence. 'It was funny to see but also humbling to observe how hard the fox had to work to find a meal. I really wanted her to be successful.' Unfortunately, she wasn't. But then the image, says Ashleigh, 'illustrates the harsh reality of winter life in Yellowstone'.

Canon EOS 7D Mark II + 500mm f4 lens; 1/640 sec at f5.6 (+1.7 e/v); ISO 1000.

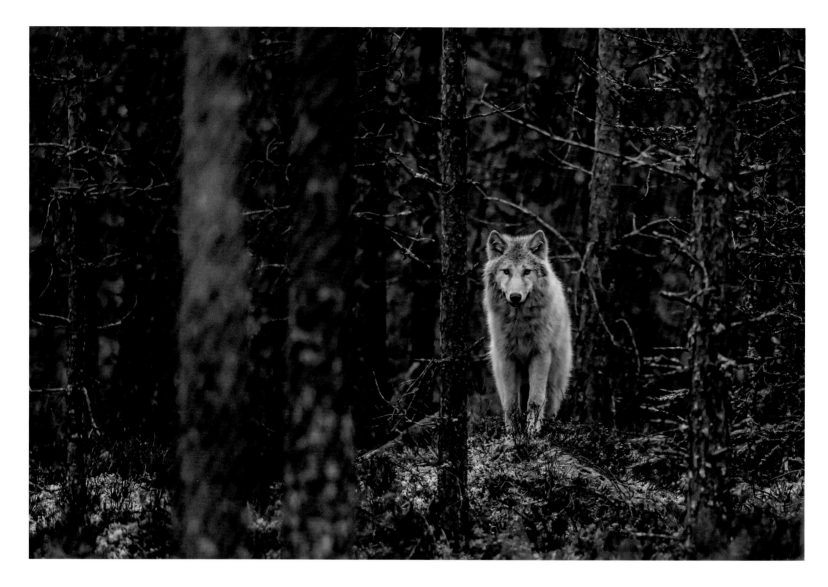

Wolf watch

Lasse Kurkela

FINLAND

Finland's wolves are hunted, legally and illegally, and so are extremely wary. Indeed, Lasse had already spent more than 50 days in photography hides in the past year without seeing any. Then in October, friends told of wolves visiting a remote hide, attracted by bait for the bears. Lasse and his father made the seven-hour journey, excitement growing as they received images on their mobiles from an automatic camera – there were wolves near the hide. Entering the hide at night, they waited. First light revealed a movement in the trees – a wolf cautiously approaching. Lasse held off before taking his first picture, his camera on quiet mode, wrapped in fabric to reduce shutter noise. He chose black and white to capture the atmosphere of the dark forest. It reminded him of the story of Little Red Riding Hood, but with a twist: 'The wolf is very scared of meeting humans. This photo tells the truth about wolves.'

Nikon D4S + 800mm f5.6 VR lens; 1/200 sec at f5.6; ISO 14400; tripod + eki gimbal head.

The hairy raincoat

Josiah Launstein

CANADA

'It rains a *lot* in Thailand in the summer,' says Josiah. But that didn't stop him exploring and discovering large monkey moth caterpillars crawling down the trees by his motel – probably on their way to hibernate in the ground – with raindrops hanging jewel-like on their long defensive and rainproofing hairs. Josiah and his father were in the mountains in northern Thailand, where Nikon was making a short film about the 11-year-old's passion for wildlife photography (he has been shooting since he was seven). He hadn't brought a macro lens with him, and so to focus, he got as close to the caterpillar as his 200–500mm lens allowed him and crouched down to silhouette it against the bright, overcast sky. 'I wanted the picture to be all about the raindrops in its hair.' Back home in Canada, he cropped in close, to emphasize the effect. 'I love how the water drops and hair clusters make it look like water is squirting out of it like little fountains... It's really easy as a wildlife photographer to get focused on the big animals and forget how cool nature is all around us. This is one of my favourite pictures from the whole trip.'

Nikon D7100 + AF-S 200–500mm f5.6 lens at 500mm; 1/200 sec at f7.1 (+0.3 e/v); ISO 640; monopod.

Glimpse of a lynx

Laura Albiac Vilas

SPAIN

Laura had seen many of Spain's wild animals, but never the elusive Iberian lynx, an endangered cat found only in two small populations in southern Spain. Unlike the larger European lynx, the Iberian lynx feeds almost entirely on rabbits. So a disease that wipes out the rabbit population can be catastrophic. They also need a particular blend of open scrub and natural cavities for natal dens. Laura's family travelled to the Sierra de Andújar Natural Park in search of the lynx – and struck lucky on their second day – a pair were relaxing not far from the road. There were many photographers there but an atmosphere of 'respect'. Laura watched for an hour and a half, the only sound being the whirr of cameras if a cat glanced in their direction. 'The animals' attitude surprised me. They weren't scared of people – they simply ignored us,' says Laura. 'I felt so emotional to be so close to them.'

Canon EOS 5D Mark III + Canon 500mm f4 lens; 1/250 sec at f4; ISO 1600.

Bear hug
Ashleigh Scully

USA

After fishing for clams at low tide, this mother brown bear was leading her young spring cubs back across the beach to the nearby meadow. But one young cub just wanted to stay and play. It was the moment Ashleigh had been waiting for. She had come to Alaska's Lake Clark National Park intent on photographing the family life of brown bears. This rich estuary environment provides a buffet for bears: grasses in the meadows, salmon in the river and clams on the shore. A large number of families spend their summers here, and with plentiful food, they are tolerant of each other (though wary of males) and of people. 'I fell in love with brown bears,' says Ashleigh, 'and their personalities... This young cub seemed to think that it was big enough to wrestle mum to the sand. As always, she played along, firm, but patient.' The result is a cameo of brown bear family life.

Canon EOS 5D Mark II + 500mm f4 lens; 1/1250 sec at f8 (+1 e/v); ISO 1250; Gitzo tripod.

Young Wildlife Photographers:
10 years and under

In the grip of the gulls

Ekaterina Bee

ITALY

Like all her family, five-and-a-half-year-old Ekaterina is fascinated by nature, and she has also been using a camera since she was four years old. But on the boat trip off the coast of central Norway, her focus was not on the white-tailed sea eagles that the others were photographing but on the cloud of herring gulls that followed the small boat as it left the harbour. They were after food, and as soon as Ekaterina threw them some bread, they surrounded her. At first she was slightly scared by their boldness and beaks but soon became totally absorbed in watching and photographing them, lost in the noise, wingbeats and colours of feet and beaks in the whirl of white. Of all the many pictures she took that day, this was the one she liked best because of the way the birds filled the white sky and the expression on the face of the bird furthest away: 'It looked very curious, as if it was trying to understand what was happening on the boat.'

Nikon D90 + 18–70mm f3.5–4.5 lens at 18mm; 1/320 sec at f11 (+0.7 e/v); ISO 400.

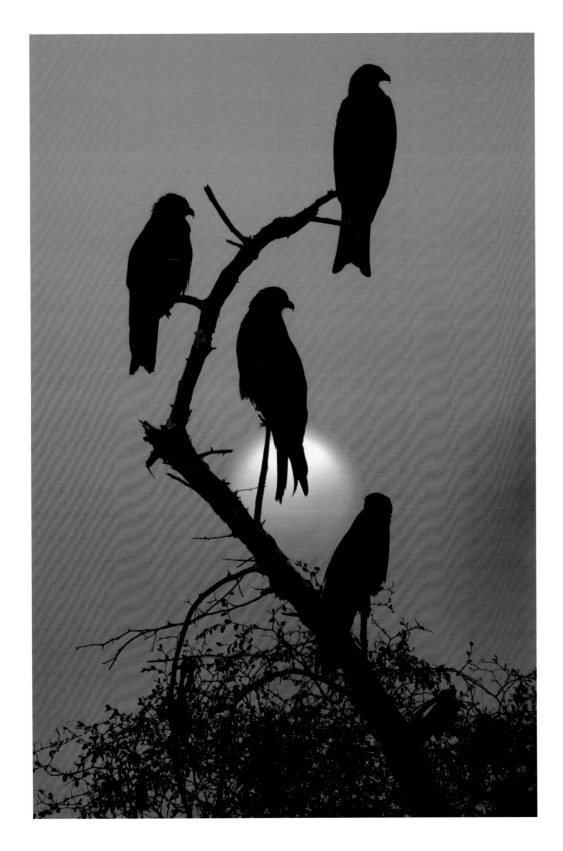

Black kites, red sunset
Dhyey Shah

INDIA

Dhyey was keen to see vultures, and so his parents took him to Rajasthan's Jorbeer Conservation Reserve, one of the most important wintering grounds for India's resident and migratory vultures. Livestock carcasses are dumped here, providing extra food for seven species of vulture, including Himalayan griffon and Egyptian, and large numbers of resident black kites. Raptors on migration, such as steppe eagle, imperial eagle and saker falcon, also scavenge here. Dhyey noticed that some of the black kites would roost in a particular tree, and inspired by a young photographer's winning picture from last year, he set out to experiment with silhouettes. He considers this his best shot, at sunset on an evening when the sky turned a vibrant red, bringing together 'the beauty of all mother nature's elements – sun, sky and wildlife'.

Canon EOS 70D + 100–400mm f4.5–5.6 lens; 1/500 sec at f5.6; ISO 400.

Road hog
Evalotta Zacek

ESTONIA

Evalotta was out for the evening on the family's customary 'animal drive' near their summer home in southern Estonia. 'My dad, my brother and I all try to spot animals and photograph them, and my mum takes pictures of us!' While looking for deer and foxes at dusk at the edge of a forest, they saw this hedgehog crossing the road ahead. Evalotta wanted to photograph it at eye level, and lay down in the road to get a low angle. But to get an even lower angle, she then got into a ditch beside the road, photographing it with the setting sun coming through the trees behind. Western European hedgehogs can travel more than a kilometre (over half a mile) a night foraging for food such as beetles, slugs, frogs and berries. They are an integral part of Estonia's rich flora and fauna, though in the south, it's the eastern European hedgehog species that's more common.

Nikon D7100 + Nikkor 70–200mm f2.8 lens at 200mm; 1/40 sec at f2.8; ISO 1600.

Cold catch
Fred Zacek
ESTONIA

Emerging onto the ice from a river in eastern Estonia, an otter shakes off excess water before eating its catch. Nearby, lying on the ice, was five-year-old Fred. It was the first time he'd seen an otter. Earlier in the week, his father had spotted it feeding on a bend in the river where there was ice-free water, but Fred had to wait to join him until Saturday, when there was no school. They got to the river at first light and were on the ice when the otter arrived. It obviously knew where to look for frogs hibernating on the riverbed – in winter, hibernating frogs can be a significant part of an otter's diet. Each time it dived, Fred slid closer – close enough to hear the otter crunching up the frogs. The otter didn't seem to mind that it was −18°C (0°F), but for Fred holding his camera, it was a challenge, and after a while he had to slide back to the riverbank to warm up his frozen hands.

Nikon D810 + Nikkor 300mm f2.8 lens; 1/1000 sec at f2.8; ISO 1600; Gitzo tripod.

When worlds collide
Fred Zacek

ESTONIA

Fred's family often spend their summers in southern Estonia near the border with Latvia, an area of rolling hills, lakes, rivers and forests, with a diversity of wildlife, including wolves and lynx and many species of birds. On summer afternoons and evenings, the family go looking for wildlife to watch and photograph. Fred has been doing this since he was two years old, when he was given his first camera. On this day, driving to a location with a large badger sett that his father had discovered, a small bird flew fast and low in front of the car. They had been driving slowly and didn't realize it had been hit, but when they arrived, five-year-old Fred was shocked to see a warbler lodged in the grille. He took a photograph 'so I could send good wishes to the dead bird', though he found it a challenge to concentrate on the photography while trying not to cry.

Nikon 1 AW1 + Nikkor 11–27.5mm f3.5–5.6 lens; 1/400 sec at f5.6; ISO 800.

The make-you-jump spider

Adam Hakim Hogg

MALAYSIA

To photograph this Malaysian *Liphistius* trapdoor spider during the split-second that it was in the open required patience. Though there used to be lots of these long-lived spiders near Adam's home in the hill country north of Kuala Lumpur, collection of them for the pet trade has meant they are now uncommon here. They are also nocturnal, and their silken trapdoors are well camouflaged with plant material. Having located a trapdoor not far from his house, Adam had to set up his camera and flash in the day, then return after dark to wait. The spider is not easily fooled by tweaking its traplines, and it took several nights for Adam to get his shot. Keeping its feet in contact with the silken traplines that radiate out from its burrow, the spider lurks behind its trapdoor. Only when an insect such as a cricket or beetle touches more than one line does the hinged trapdoor spring open and the spider leap out to grab its prey. 'It comes out like a bullet,' says Adam. 'It makes you jump every time, and many times it's back inside before you can press the shutter.' Adam loves the thrill of night-time wildlife-watching with his father, exploring the rainforest around their home, and he is especially intrigued by the trapdoor spider, having learnt just how ancient the species is. 'It was roaming the Earth at the time of the dinosaurs, looking just as it does now... It's criminal that it is now rare because people dig it up.'

Canon EOS 500D + 100mm f2.8 lens; 1/125 sec at f11; ISO 800; Speedlite flash; Gitzo tripod.

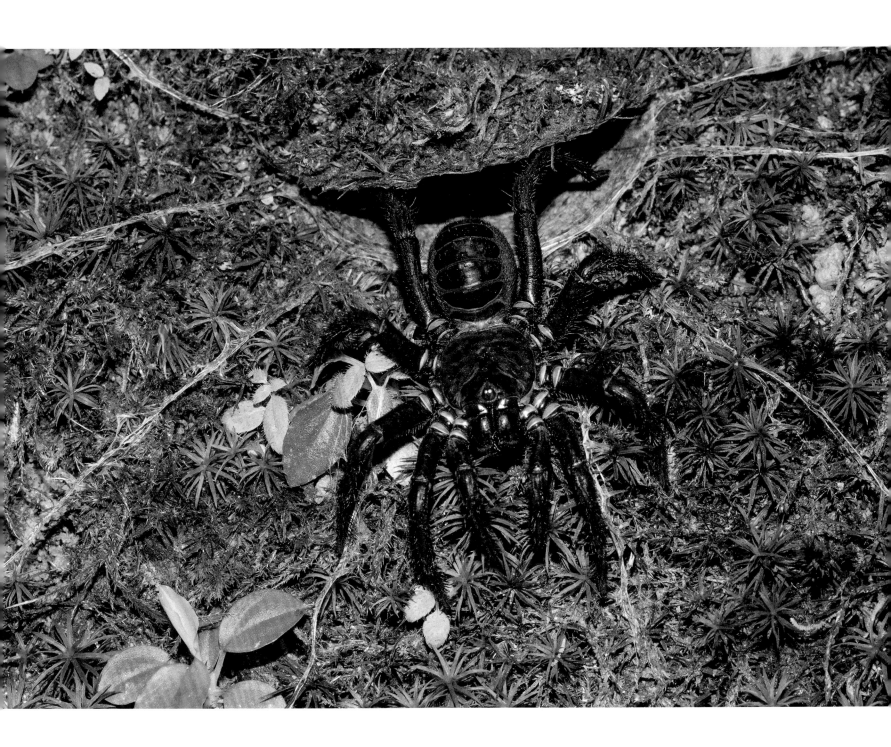

Index of Photographers

146
Laura Albiac Vilas
SPAIN
lauraalbiac@gmail.com

138
Marc Albiac
SPAIN
marcalbiac@gmail.com

139
Knut Erik Alnæs
NORWAY
www.keanaturephotography.com

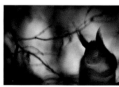

67
Mats Andersson
SWEDEN
www.matsandersson.nu

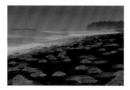

52
Ingo Arndt
GERMANY
www.ingoarndt.com
Agents
www.mindenpictures.com
www.naturepl.com

50
Javier Aznar González de Rueda
SPAIN
www.javier-aznar-photography.com

60, 76
Laurent Ballesta
FRANCE
www.blancpain-ocean-commitment.com/
en-us#!/photographer/laurent-ballesta

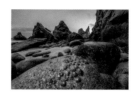

148
Ekaterina Bee
ITALY
alessandrobee@hotmail.com

104
Anthony Berberian
FRANCE
www.anthonyberberian.photoshelter.com

94
Dorin Bofan
ROMANIA
www.dorinbofan.com

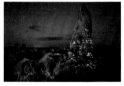

89, 100
Theo Bosboom
THE NETHERLANDS
www.theobosboom.nl

78
Chris Bray
AUSTRALIA
www.chrisbrayphotography.com

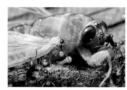

40
Lucas Bustamante
ECUADOR
www.tropicalherping.com

84
Marcio Cabral
BRAZIL
www.fotoexplorer.com

88
Mark Cale
UK
www.markcale.com

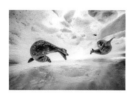

109
Jordi Chias Pujol
SPAIN
www.uwaterphoto.com
Agent
www.naturepl.com

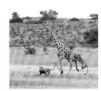

62
Michael Cohen
USA
www.mykey.smugmug.com

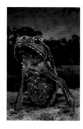

27, 74
Jaime Culebras
SPAIN
www.photowildlifetours.com

20
Peter Delaney
IRELAND/SOUTH AFRICA
www.peterdelaneyphotography.com

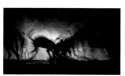

68
Greg du Toit
SOUTH AFRICA
www.gregdutoit.com

102
Jack Dykinga
USA
www.dykinga.com
Agent
www.naturepl.com

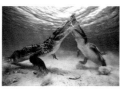

64
Eilo Elvinger
LUXEMBOURG
www.eilophotography.com

51
Rodrigo Friscione Wyssmann
MEXICO
www.rodrigofriscione.com

98
Uge Fuertes Sanz
SPAIN
www.ugefuertes.com

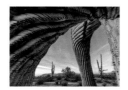

114
Aaron 'Bertie' Gekoski
UK/USA
www.aarongekoski.com
Agent
www.scubazooimages.com

38
Justin Gilligan
AUSTRALIA
www.justingilligan.com

73
Roberto González García
SPAIN
rglezgarcia10@gmail.com

28
Sergey Gorshkov
RUSSIA
www.gorshkov-photo.com
Agents
www.mindenpictures.com
www.naturepl.com

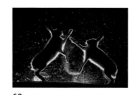

69
Erlend Haarberg
NORWAY
www.haarbergphoto.com
Agents
www.natgeocreative.com/
photography/erlendhaarberg
www.naturepl.com
www.scanpix.no

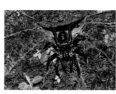

154
Adam Hakim Hogg
MALAYSIA
stephen.wildtrack@gmail.com

121
Charlie Hamilton James
UK
www.charliehamiltonjames.com
Agent
www.natgeocreative.com

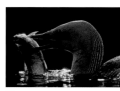

33
Jari Heikkinen
FINLAND
jari.heikkinen@ppq.inet.f

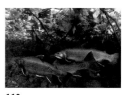

110
David Herasimtschuk
USA
www.freshwatersillustrated.org

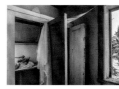

75
Pål Hermansen
NORWAY
www.palhermansen.com
Agent
www.naturepl.com

108
Edwar Herreno
COLOMBIA/COSTA RICA
www.edwarherreno.com

122
Justin Hofman
USA
www.justin-hofman.com

26
Wade Hughes
AUSTRALIA
www.wadeandrobynhughes.com

61
George Karbus
CZECH REPUBLIC/IRELAND
www.georgekarbusphotography.com

34
Tyohar Kastiel
ISRAEL
www.tyohar.org

144
Lasse Kurkela
FINLAND
www.lassekurkela.kuvat.fi

141
Russell Laman
USA
www.russlaman.com
Agent
www.naturepl.com

145
Josiah Launstein
CANADA
www.launsteinimagery.
com
Agent
john@launsteinimagery.com

82
Reiner Leifried
GERMANY
www.reinerleifried-photography.de

112
Qing Lin
CHINA
linqingdiver@qq.com

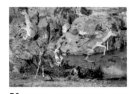

22
David Lloyd
NEW ZEALAND/UK
www.davidlloyd.net

79
Angiolo Manetti
ITALY
www.angiolomanetti.it

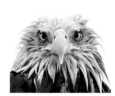

120
Bence Máté
HUNGARY
www.bencemate.com
Agent
Andrea Reichenberger
office@matebence.hu

117
Robin Moore
UK
www.robindmoore.com

56
John Mullineux
SOUTH AFRICA
www.facebook.com/jmximages

46
Andrey Narchuk
RUSSIA
www.narchuk.com

136
Daniël Nelson
THE NETHERLANDS
www.danielnelson.nl

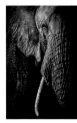

24
Klaus Nigge
GERMANY
www.nigge.com
Agent
www.natgeocreative.com

140
Dhanu Paran
INDIA

90
David Pattyn
BELGIUM
www.dpwildlife.com
Agent
www.naturepl.com

30
Gerry Pearce
UK/AUSTRALIA
www.australian-wildlife.com

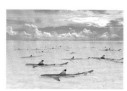

12-19
Thomas P Peschak
GERMANY/SOUTH AFRICA
thomas@thomaspeschak.com
www.thomaspeschak.com
Agent
www.natgeocreative.com

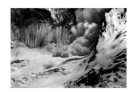

42
Imre Potyó
HUNGARY
poimre@gmail.com

96
Michel Roggo
SWITZERLAND
www.roggo.ch

86
Jaime Rojo
SPAIN
www.rojovisuals.com

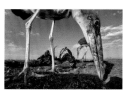

32
Daniel Rosengren
SWEDEN
www.danielrosengren.se

80
Paddy Scott
UK
www.paddyscott.com

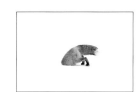

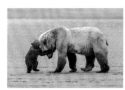

142, 147
Ashleigh Scully
USA
www.ashleighscullyphotography.com

150
Dhyey Shah
INDIA
ketanrinku@yahoo.com

66
Santosh Shanmuga
USA
www.shanmugaphotography.com

106
Alex Sher
USA
www.alexsherphoto.com

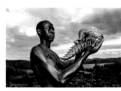

48
Brian Skerry
USA
www.BrianSkerry.com
Agent
www.natgeocreative.com

116
Adrian Steirn
AUSTRALIA
www.adriansteirn.com

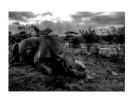

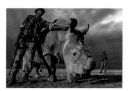

10, 124–129
Brent Stirton
SOUTH AFRICA
www.brentstirton.com
Agent
www.gettyimages.com

92
Klaus Tamm
GERMANY
www.tamm-photography.com

41, 44
Kutub Uddin
BANGLADESH/UK
www.kutubuddin.photography

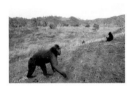

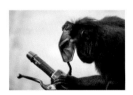

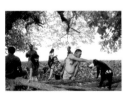

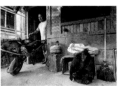

70, 130–135
Stefano Unterthiner
ITALY
www.stefanounterthiner.com

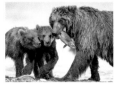

58
Marco Urso
ITALY
www.photoxplorica.com

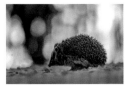

72
Hugo Wassermann
ITALY
www.hugo-wassermann.it

118
Steve Winter
USA
www.stevewinterphoto.com
Agent
www.natgeocreative.com

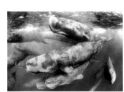

54
Tony Wu
USA
www.tonywublog.com
Agent
www.naturepl.com

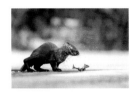

151
Evalotta Zacek
ESTONIA
sven@zacekfoto.ee

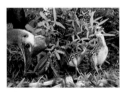

152, 153
Fred Zacek
ESTONIA
sven@zacekfoto.ee

36
Christian Ziegler
GERMANY
www.christianziegler.photography
Agents
www.mindenpictures.com
www.natgeocreative.com